African American
Visual Aesthetics

African American
Visual Aesthetics

A POSTMODERNIST VIEW

▤▦▥ Edited by DAVID C. DRISKELL

SMITHSONIAN INSTITUTION PRESS

WASHINGTON ◆ LONDON

© 1995 by the Smithsonian Institution
All rights reserved

"The Negro Speaks of Rivers," from Langston
Hughes, *Selected Poems,* copyright 1926 by Alfred A.
Knopf and renewed 1954 by Langston Hughes, is re-
printed by permission of the publisher.

Copy Editor: Marcia Schifanelli
Production Editor: Jenelle Walthour
Designer: Kathleen Sims

Library of Congress Cataloging-in-Publication Data
African American visual aesthetics: a postmodernist
 view / edited by David C. Driskell.
 p. cm.
 Includes bibliographical references.
 ISBN 1–56098–605–0
 1. Afro-American Art. 2. Art, Modern—20th
century—United States. 3. Postmodernism.
 I. Driskell, David C.
 N6538.N5A347 1995
 704′.0396073—dc20 95–10256

British Library Cataloguing-in-Publication Data is
available

Manufactured in the United States of America
01 00 99 98 97 96 95 5 4 3 2 1

⊗ The paper used in this publication meets the mini-
mum requirements of the American National Stan-
dard for Permanence of Paper for Printed Library Ma-
terials Z39.48–1984.

For permission to reproduce illustrations appearing in
this book, please correspond directly with the owners
of the works, as listed in the individual captions. The
Smithsonian Institution Press does not retain repro-
duction rights for these illustrations individually, or
maintain a file of addresses for photo sources.

Contents

Plates follow page 78

Acknowledgments

In the 1960s, one would have had strong reservations about publishing a collection of essays that poignantly dealt with the subject of postmodernism. Some would have thought it an irrelevant topic. And yet traits of postmodernism, the period of art that has come to be looked upon as the aftermath of the modernist movement, appeared in the work of African American artists such as Hale Woodruff, Aaron Douglas, and Sargent Johnson as early on as the decades of the twenties and thirties. One writer stands out among those who saw the emerging artistry of artists of African ancestry as an important ingredient in the modern art movement. This person was none other than Alain Locke. He was the chief spokesperson for the Negro artist in the period of the Harlem Renaissance.

Several of the writers, including myself, who contributed essays to this publication have noted the significance of Locke's pioneering work early in the century as a writer who proclaimed the importance of the Negro artist in American cultural his-

tory. Without Locke's insistence that African American artists heed the sound lessons of modernism by looking to the arts of Africa for creative inspiration, there would be little recognition today of the African ancestral legacy in Western art.

Indeed, African American and European artists began borrowing elements from the art of Africa in the late nineteenth and early twentieth centuries. Symbols of Africa appear in the art created by Aaron Douglas and Sargent Johnson in the 1920s and 1930s. They relied heavily on motifs of African masks and statues to evoke their ancestral legacy. European masters such as Picasso, Modigliani, and Brancusi used elements from African art to create new forms of expression in modernism.

These ideas are further explored in this collection of essays. They evolved from a series of papers delivered at a symposium entitled "The African-American Aesthetic in the Visual Arts and Postmodernism" that took place at the Hirshhorn Museum in the spring of 1991.

This publication would have not have been possible without the help and encouragement of several people. Teresia Bush of the Hirshhorn had the insight to organize the symposium and foresee the need for documentation on this topic. Sincere appreciation must also go to the essayists: Keith Morrison, Dean of the College of Fine Arts at San Francisco State University, agreed to write the lead essay; Ann Gibson labored under undue strain after a serious automobile accident to revise her essay; Sharon Patton provided information and editorial suggestions beyond the call of duty; Lowery Sims was the first writer to submit her essay for publication; and Rick Powell was always there when I needed him despite curating the William H. Johnson exhibition *Homecoming* at the Smithsonian and fulfilling his duties at Harvard University as a fellow at the W. E. B. DuBois Institute.

I am particularly indebted to my daughter, Daphne Driskell-Coles, who worked patiently as typist and office assistant during the long and arduous review of the

manuscript. Credit is also due to Darius, Driskell, and Ophelia Speight, Reneé Hanks, and Rodney Moore, who provided invaluable research assistance in the early stages of my writing the introduction to these essays.

More importantly, the essayists join me in thanking the many artists whose creative efforts inspired the notion that a postmodernist examination of their work would be an important contribution to twenty-first-century aesthetic thought. For the encouragement given us by Amy Pastan and other staff at the Smithsonian Institution Press, we offer our gratitude.

Introduction

The Progenitors of a Postmodernist Review of African American Art

DAVID C. DRISKELL

In the spring of 1991, a number of artists and writers, many of whom have depicted African American iconography in their works of art or discussed it in their writings, gathered at the Hirshhorn Museum and Sculpture Garden at the Smithsonian Institution to speak at a symposium entitled "The African-American Aesthetic in the Visual Arts and Postmodernism," cosponsored by the Hirshhorn and the College of Fine Arts, Howard University. Although relevant issues of art history were discussed, in the main, the symposium topics centered on ways to promote independence for African American artists from the prevailing European models.

Much of the art of African Americans combines subjects from black popular culture with modernist styles. But two speakers noted that Pablo Picasso and Karl

Schmidt-Rottluff had looked to the arts of Africa in their pursuit of a modernist posture for their art early in the twentieth century, a fact seldom mentioned in the major compendia. Not surprisingly, African American artists in the mid–1920s did the same. Hence a new movement in modernism was born that reflected the art of ancient Africa recreated in the diaspora. This movement influenced the progenitors of a postmodernist view of African American aesthetics, particularly those who called for black artists to see Africa as the inspiring source for their work.

Some speakers revealed that African American artists are including more autobiographical references in their work, thereby creating a highly personal art that broadens the visual imagery of the African American beyond the limited view of writers of the majority culture. But to say that such a trend implies that artistic independence for black artists is possible in Euro-America is misleading, since most of the standards by which black culture is judged have come from critics who are not black, a curious dichotomy. The few exceptions were the writers Alain Leroy Locke (1885–1954), James Vernon Herring (1887–1969), and James Amos Porter (1905–1970), who are regarded as the progenitors of a postmodernist review of aesthetics and African American art.

The subject of postmodernism and the African American aesthetic has become more widely discussed in the 1990s than it was in previous years, principally because art historians have made what is considered a weak attempt to bring diversity to the discipline by including participants who represent all Americans, particularly African Americans.[1] The difference in the way African Americans and Euro-Americans view their art constitutes an important division in the interpretation of postmodernism. The art of African Americans is often autobiographical, frequently depicts black subjects, and expresses the artist's open-ended attitude about issues of race, ethnicity,

sexual preference, and gender. Most of the speakers felt that such issues were not always addressed in Eurocentric art.

Often overlooked in current discussions of postmodernism is that the formation of black aesthetics is not a recent development but began some time ago. In the early part of the century, it was thought that in order for African American artists to have a racially inspired set of artistic principles, a spokesperson would have to come forward to define a set of standards. Locke filled the void. He was joined by Herring in the 1920s and later by Porter, their former student, in speaking eloquently for artists of color by defining their contributions to modern American art.[2]

When the founding scholars of African American art history, principally Herring, Locke, and Porter, began writing on the subject of Negro contributions to American art in the 1930s, black artists still lacked a system of racially based aesthetics, nor had any scholar addressed the factual omissions of importance to blacks in the compendia.[3] Yet issues of a racially based aesthetic in the visual arts were touched upon by Locke as early as 1916, when he delivered a series of lectures on race and culture to the faculty of the College of Liberal Arts at Howard University.[4] But neither Locke nor Herring addressed, in the main, the larger issue of racial aesthetics by discussing how artists of color could delineate form in ways that adhered to the principles of modern art yet also recalled their African heritage. Locke addressed the issue of African-inspired subject matter in his famous appeal to Negro artists to return to the ancestral arts of Africa for inspiration in their work as early as 1925.[5] Indeed, Locke and Herring, who were often at odds with each other on matters of aesthetic taste, were united on the subject of the immediate need for Negro artists to claim their rightful place in American society by establishing an area of study and a philosophical direction that centered first on themselves but also on the history of

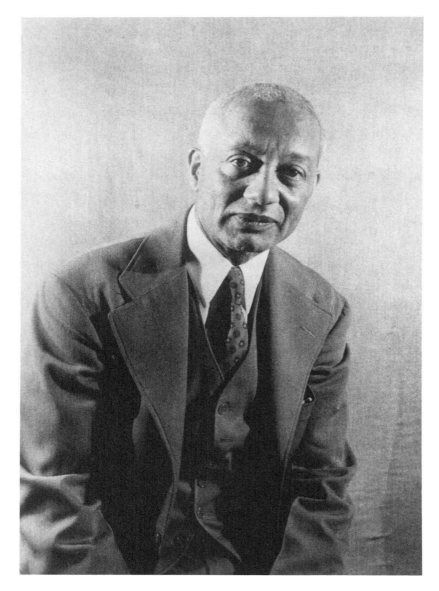

Figure 1

Carl Van Vechten.
Alain Locke.
Black and white
photograph.
8 × 10 in.
Estate of Carl Van
Vechten. Gravure and
compilation. The
Eakins Press
Foundation.

their people. In this regard, the place to examine African American art theories in the 1930s became the Department of Art at Howard University, not the ivory towers of the Ivy League schools of the East.

When Herring and Locke pursued their dream of establishing a modern school of art in which African American artists would be in touch with their own racially based aesthetic, they were unaware that a vast territory of scholarly studies that would produce an objective view of African history and culture in the diaspora lay just beyond the horizon. Of prime importance to those who study black cultural history is knowing what was in the minds of those pioneers who saw the need to redirect those artists aspiring to greatness away from accepted white traditions to the creation of a racially based art that depicts blacks in a positive light. Importantly, they wanted black artists to have the true knowledge of their African heritage, which would lead to a greater ability to express artistically who they are. Such knowledge might also lead to a clearer understanding of the process by which one could objectively analyze historical and cultural events. Applying this process to African American culture would involve using Euro-American methods of analysis. But was this not a part of the problem at hand: the assimilation of the European model already in place? Was this not the place where the Negro artist was excluded and rumored to have faint understanding of the modernist postulates of art?

The many questions that arose in the formal discussions among Herring, Locke, and Porter included the following: (1) Who should define artistic standards for the race, and should the definitions not come from within? (2) What is the relevance of traditional art historical studies to blacks when those studies make no reference to the work of African American artists? (3) How do we address the depiction of stereotypes and negative imagery reflecting the black race in American art, particularly when these images seem to be an acceptable part of white culture? (4) How did the

European concept of the African personality, as realized in art, affect the writing of art history in the nineteenth and twentieth centuries? (5) How do we view the sociopolitical interpretation of black subjects in American art? (6) Can black writers alter the negative course of events that followed what was often a campaign waged by writers of the majority culture to mock the black race? (7) How should the writings on African American art and aesthetics by majority culture critics and art historians be viewed?

Locke determined that addressing the glaring omissions of a racially biased art establishment in America, which acknowledged the contributions of artists of European ancestry only, demanded that black scholars take matters into hand and unearth those documents that would inform the nation about the history of African American accomplishments in the visual arts from slavery to modern times. Oddly enough, some sixty years after this declaration, a group of concerned scholars of both races from across the nation came to Washington, D.C., to outline some of the same concerns about aesthetics and about helping the African American to enter mainstream art as those pioneering scholars who had written on the subject in the 1930s. It stands to reason that neither Herring, Locke, nor Porter would find the topic postmodernism and the African American aesthetic alien to their scholarly review.

Indeed, it was they, in the 1930s and 1940s, who first raised the important topics in African American aesthetics that scholars still discuss today. In an attempt to place the African American aesthetic in the larger context of American art, these early scholars stressed the need for writers on the subject of race and culture to research their own history and pursue scholarship centering on the discovery of their African heritage and a definition of a prideful self. They reasoned that black artists needed to turn inward for inspiration that would enable them to produce new images of

themselves that were void of negative references. Sharon Patton, writing on the bold and innovative work of three contemporary African American artists who are women, reaffirms this same notion with her thesis of a canon void of influences outside the race. In like manner, Ann Gibson reminds us that issues such as identity, autobiography, self-definition, racism, and ethnic tradition have proven threatening to Eurocentric art historians. But these elements are the wellsprings from which many African American artists draw their content. As Lowery Stokes Sims points out in her essay, overcoming the myths reinforced by white writers became a major challenge for the black race as they sought a positive image. This was particularly true for artists of African ancestry who exhibited in the United States, such as Wifredo Lam, Robert Colescott, Romare Bearden, and Norman Lewis.

Early African American scholars noted that what was most needed in critical circles was a scholarly compendium that began not with the enslavement of the African in the New World, but with the history of the ancient empires of the African past where art played a central role in birth, life, and death. These scholars considered the ancient art of Egypt, Ife, and Benin, whose images reappear in the work of several contemporary artists, the first chapter in the history of African art. These early scholars felt that they could bring about a renaissance of black culture as they published the results of their studies of black cultural history in America, a renaissance that would give impetus to the aesthetic inquiry underway in black educational circles.

Among the first modern publications to address the issue of the aesthetics of African American art was Locke's *Negro Art: Past and Present*. Published in 1936, it seemed elementary even then, but it was an important beginning. *Negro Art* attempted to survey the field, connecting the history of African Americans' artistry to that of their forbearers in Africa. Locke, who was well versed in critical methodology, did not attempt to apply the formula of so-called standard criticism to the art he

cited. Standard criticism in the 1930s was an exclusionary practice of white writers since it did not address the subject of the Negro in art and seldom addressed the art created by women. Although Locke asked relevant questions about the work cited, his questions were meant to cause the reader to search for a wider understanding of what was later labeled the Negro's latent talent, rather than make inquiry into a given aesthetic direction.[6]

Prior to 1936, a number of well-respected black scholars, among them W. E. B. DuBois and Benjamin Brawley, wrote about black creativity in the arts in *Crisis* and *Opportunity* magazines, both of which dealt principally with racial issues in the Negro's quest for equality. In the main, readers of these publications were not interested in the critical analysis of works of art by African Americans. But the editors reported on the major aesthetic developments in the African American art community. In many ways, a sense of commitment to Negro culture was born inadvertently at a time when few journals in America showed interest in the new modernist view of African American art.

As Locke's reputation as a philosopher, critic, and aesthetician grew, art organizations often turned to him to comment upon the progress of the race in major creative endeavors. When the Albany Institute of History and Art organized the most comprehensive exhibition of works by African American artists assembled to date in 1945, the institute asked him to validate those who were selected as exhibiting artists.[7] The Harmon Foundation, under the leadership of Mary B. Brady, singled Locke out as the spokesperson for the race by selecting him to be the judge and commentator for much of the art that appeared in the foundation's series of annual exhibitions entitled *Work by Negro Artists* held in the 1920s and the 1930s.[8] This position of progenitor and overseer of black creative thought placed Locke in the forefront of viewing the Negro artist in a modernist context.

Locke's *Negro Art* presented a black view of history from the mind of an eminent black scholar, an important beginning in forming a modern concept of the black artist. But perhaps even more important was that Locke had put forth a set of postulates in modern aesthetics in an anthology of essays called *The New Negro* as early as 1925.[9] There, as in *Negro Art,* his aim was to create among African American artists a bold iconoclast break with the representational style of the art of the past and point African American artists away from what he thought was a stale form of modernism in the European mode.[10] At the same time, Locke implored his colleagues to join him in a revisionist writing of American art history that would include the contributions of artists of African ancestry. Such a stance at that time was a lonely one often open to critical rebuke. Clearly, he would need great powers of persuasion to convince a skeptical world that history was indeed rendered sentimentally and subjectively regarding the black race. Despite Locke's efforts, such an enlightened point of view would not be forthcoming in his lifetime.

This enlightened and scholarly approach to the subject of a revised and more modernist view of a black aesthetic in African American art was taking place at about the same time that the New Negro Movement was becoming widely known. The result was an outpouring of creativity in Harlem in the arts in the period we now call the Harlem Renaissance.[11] With the advent of the political nationalism of Marcus Garvey and the socioeconomic theories of W. E. B. DuBois, a quest began for an equitable social order that aimed to boost economic and cultural opportunities for African Americans throughout the nation. It was assumed that social change would help validate a racially based ethos in art that would in turn promote cultural empowerment in the black community. That a notion of such cultural significance was emerging in the 1920s, the same decade that Howard University's art department was founded, attests to the soundness of mind and salient vision that these pioneer-

ing scholars brought to the discipline at an early age. Their writings, in many ways, can be looked upon as the catalyst of the postmodernist review of black achievements in the visual arts that is occurring today.

Yet it is here that one of the major problems of aesthetics in African American art was duly confronted but only partially solved. Locke, Herring, and Porter made a bold iconoclast break with the European mind-set by objectively outlining a history in which peoples of color were cited for the first time for their salient achievements in art independent of European and American writings. But full recognition of Locke, Herring, and Porter's plan did not occur at that time. This assertion is made with the realization that African Americans had to put forth, independent of European scholarship, those truths of their own history, identity, and culture as well as of their own self-determination as a people. But there were few tools in place in the discipline by which this could be done without white approval.

One is aware that, contrary to popular belief, history is seldom truly objective. It does not flow unaltered by subjective beliefs. For this reason, the main purpose of the historian is to discover the truth and to weed out so called "facts" tainted with racial bias. The true history of African American visual culture when objectively rendered shall serve as a blueprint of the achievements of a people whose art has survived under exceedingly great odds. But often truth is tampered with to distort the records of history.[12] So like Locke in his assessment of the historical progress of African American artists in his day, current scholars realize that much of African American cultural history remains saliently recorded in the deeds of artistry that are perhaps buried away in the archives and unexplored repositories. A case in point is the abundance of heretofore untapped information that has come to our attention in recent years from a number of exhibitions centering on African American artists of the nineteenth and twentieth centuries. But to further affirm the legacy of a post-

modernist neglect in the review of African American aesthetics, it is important that we return to some of the problems that surfaced early on in the discipline, many of which we continue to review.

Some of the most pressing problems of aesthetics in African American art noted in the 1930s remain unsolved. They pertain to the definition of art and who should make such cultural definitions for the race. In their attempt to find answers, scholars cannot consult prior writings of history as little of the artistry of African Americans has been documented in standard history books. Nominal references to Edward Mitchell Bannister and Henry O. Tanner appeared in William J. Simmon's biographical study of black leaders entitled *Men of Mark: Eminent, Progressive, and Rising*, published in 1887. European art catalogues and cultural publications later acknowledged the creative talent of sculptors Edmonia Lewis and Meta Warrick Fuller, both of whom worked in Europe prior to the turn of the century.

But the misrepresentation of black subjects in art and the widespread depiction of negative images of the black race remained to be addressed. Early on, Locke saw a strong need for the affirmation of the contributions of African American artists by white writers on the arts of the United States, yet little progress could be pointed to in this direction as late as the 1990s. There remains the need to critically examine those writings about black artistry from outside the culture (by majority culture writers) for historical accuracy, for the perpetuation of popular myths, and the reintroduction of stereotypes. The question of who is defining whom and what are the so-called standards of quality by which blacks and their artistry are judged remains. For example, when a white image is depicted by white artists, mainstream critics and museum curators see it as a universal or genre image, but when a black image is depicted by blacks, it is thought to be ethnic or more threatening than universal. These questions will have far-reaching significance for African American scholars as

they study European art methodology, subjects, and pedagogy. In the same manner, Richard Powell in his essay asks why an artist whose art is so relevant to American culture as that made by David Hammons is seldom celebrated within the mainstream. Is it simply because black images and symbols are often at the core of Hammons's work?

Everyone who writes decides on the subject and writes from a particular point of view. Ask black scholars and the public in general—Who is the greatest African American painter? They might respond, Henry O. Tanner. Ask white scholars and museum officials the same question; they might respond, Horace Pippin. Ask yourself the question—Why is this true? A crucial issue in one's answer should be the writing of African American art history. When the history is based in the critical examination of primary sources and authentic materials, a synthesis of informed opinion can be accurately rendered. African Americans view Tanner as a highly accomplished painter whose work is competitive with white mainstream artists of his day, and often surpassed theirs in public acknowledgement of skillful execution. Pippin's work is seen by African Americans as fundamental to a clear understanding of the wide range of their artistry, from the academic to the folk tradition. They note a white assessment of Pippin as a *primitive,* and an artist whose work is naive and emotionally rendered from the heart, therefore less intellectually demanding.[13]

Although Locke, Porter, and Herring set us on a course of self-discovery in African American aesthetics in the 1930s, our methods in art history have changed little since then. Our notions of scholarship in art history are most often informed by a Eurocentric view of process and methodology. This method of art historical study is patterned after the study of nineteenth-century history and includes methods borrowed from ethnography and archeology, as well as a visual examination of the object. Our education is based on Western philosophical thought. This is a fact of life.

Much of what we know today as historical methodology comes from the writings of Johann Joachim Winkelmann (1717–1768), a German historian whose main interest was the study of the classical art of ancient Greece. Winkelmann, like so many of his contemporaries, believed that Greek art emanated solely from the genius of the Greek mind. Nothing could have been further from the truth. Winkelmann viewed Roman art in the same way—citing the originality of both Greek and Roman forms as all but divinely inspired. There is no mention of the Egyptian (African) sources of Greek and Roman art in Winkelmann's historical overview. Yet, his radically biased writings have set the stage for the dissemination of one hundred years of art historical misinformation lasting into our own time.

Heinrich Wölfflin (1864–1945), a Swiss art historian, wrote treatises that reinforced Winkelmann's belief that the art of non-European cultures should be relegated to the ethnographic category. Other historians and theoreticians of beauty in the nineteenth and twentieth centuries promoted European ideals of beauty without consideration of those of nonwhite societies around the world. We have received this information without critical examination of its sources. Locke, and Porter in particular, questioned the American canon that did not include art by African Americans as do the writers of these essays.

Thus, with a steady diet of classical ideals being fed artists, art historians, and collectors of art alike, one is able to see how racist methodology and subject matter entered the discipline of art history in the early years. Regrettably, few changes have occurred in the format of art historical studies since the late nineteenth century measurably affecting how we view African American aesthetics.

The aim of the art historical process, as with all disciplines, is to search out truth and render it objectively in a systematic body of writings. In order for this to happen, history must be written in a humane way that gives validity to the highest

standards of scholarship. Locke and Porter provided new insight into a wide range of issues relevant to cultural independence. Herring provided the forum of a school, a Department of Art, where discussion of these issues could take place. These three scholars articulated a philosophical position in art that departs from the tenets that Euro-American art historians hold. Although Locke, Herring, and Porter helped to define the new aesthetic in African American art, their main concern was showing us how to arrive at the truth of our cultural past. These scholars were leading the way in defining a revisionist, indeed a postmodernist approach to American art. African Americans have not always been so lucky to have their artistry considered worthy of such a truthful recording.

Notes

1. Lucy Lippard, "Mapping," in *Mixed Blessings: New Art in a Multicultural America* (New York: Pantheon, 1990), 5–6.

2. James A. Porter, *Modern Negro Art* (New York: Dryden Press, 1943), 96–112.

3. The term Negro was in constant use during the period 1920–1960. In the 1920s James V. Herring founded the art department at Howard University, the first such program in a predominantly black institution of higher learning. James A. Porter became his first student of African American art history and joined the Howard art faculty in 1927. Alain L. Locke became the first African American Rhodes Scholar and taught philosophy at Howard University until his death in 1954.

4. Jeffrey Stewart, *The Critical Temper of Alain Locke: A Selection of His Essays on Art and Culture* (Durham, N.C.: Duke University Press, 1993).

5. For a more concise review of Locke's appeal to African American artists to use African sources in their work, see David C. Driskell, "Black Aesthetic Directions without Critical Portfolio," in *Choosing*, ed. Arna A. Bontemps (Washington, D.C.: Museum Press, 1986), 14.

6. Alain L. Locke, *Negro Art: Past and Present* (Washington, D.C.: Associates in Negro Folk Education, 1936), 5.

7. Albany Institute of History and Art, *The Negro Artist Comes of Age: A National Survey of Contemporary American Artists*

(Albany, N.Y.: Albany Institute of History and Art, 1945).

8. See David C. Driskell, "Mary Beattie Brady and the Administration of the Harmon Foundation," in *Against the Odds,* ed. Gary A. Reynolds and Beryl J. Wright (Newark: The Newark Museum, 1989), 65. Alain Locke was highly regarded by collectors. He wrote the foreword to the catalogue of the Blondiao Theater Arts Collection and engaged in dialogue with Albert Barnes about African American artists who studied at the Barnes Foundation in Merion, Pennsylvania.

9. Alain L. Locke, *The New Negro* (New York: Albert and Charles Boni, 1925), 3–16.

10. David C. Driskell, *Two Centuries of Black American Art, 1750–1950* (New York: Alfred A. Knopf, 1976), 59.

11. David L. Lewis, *When Harlem Was in Vogue* (New York: Vintage Books, 1982), 51–88. Also see David C. Driskell, "The Flowering of the Harlem Renaissance," in *Harlem Renaissance: Art of Black America* (New York: Harry N. Abrams, 1987), 105–54.

12. Jacques Barzun, "Where Is History Now?" in *The Culture We Deserve: Where Is History Now?* (Middleton, Conn.: Wesleyan University Press, 1989), 61.

13. Judith E. Stein, *I Tell My Heart: The Art of Horace Pippin* (Philadelphia: Pennsylvania Academy of the Fine Arts, 1993), 29–36.

1

The Global Village of African American Art

KEITH MORRISON

Yet, artists of color—a group with an especially large stake in current interrogations of Western hegemony—all too often remained curiously outside the purview of precisely those critics most identified with so-called new theory.

JUDITH WILSON[1]

Modernism—lets describe it loosely as the ideology behind European colonialism and imperialism—involved a conviction that all cultures would ultimately be united, because they would all be Westernized. . . . Post-Modernism has a different vision of the relation between sameness and difference: the hope that instead of difference being submerged in sameness, sameness and difference can somehow contain and maintain one another. . . .

THOMAS McEVILLEY[2]

⊞⦂⊞ Does postmodernism exist outside of Eurocentrisim? Is it central to the art of people of color? Were African American artists ever closer than the fringe of modernism? At no time during the period of modern art (say, from Manet to Warhol) was there ever an African American concept that was important to the "canon." The major African American concepts have been left below the radar of Eurocentric art. Postmodernism, the revision of Eurocentric global hegemony, is a civil war between the Eurocentric past and its present. The search for a definition of African American art opens into the reality of pan-Africanism, a concept arising from the increasing diversity of people of African descent in the United States. Today's African Americans come from every continent. They are called "black" because the most minuscule percentage of black blood in their veins makes them so in America, where even if most of their blood is white it changes nothing (any Asian blood merely reinforces their "coloredness"). Black blood mixed with white blood is always black. Only all-white blood is white.[3] "Black" or "African American" is, therefore, not a scientific distinction, not a matter of genetics, but a labeling of one's appearance. Black is a political categorization as much as it is a racial one. Ever conscious of their common political reality, artists of any degree of African ancestry create a cultural matrix from the definition imposed on them. [4]

Fragments of today's African American art come from beyond these shores but have blended with foundations laid here early. By the first quarter of this century, threads that would weave an African American alternative to modernism were evident. One approach was to explore the African American experience from the context of Euro-American art. Henry Tanner studied and painted in the United States and France.[5] He borrowed techniques from Thomas Eakins and Rembrandt van Rijn, but his subject matter and expression came from his experiences as a black man. Although he worked in France in the heyday of impressionism, he was not part of the European modernist movement. Tanner's tack of using European technique to

show African American insights has been explored by other talented African American artists. By midcentury, a number of them had created exciting alternatives to trends in contemporary American art. Among them was Richard Hunt, who achieved international acclaim in the 1950s. His sculpture shows the influence of Pablo Picasso and Julio Gonzalez. Hunt's welded steel forms seem like drawings in space, and the designs suggest plant life. Not purely abstract like so much art of this decade, his work blends methods of modern machinery with motifs from the natural world. Hunt's work is also related in concept and structure to West African metal works.[6]

Barbara Chase-Riboud creates abstract metal sculpture of African American imagery.[7] She uses the modernist medium of assemblage to create works that are reminiscent of slave-craft and fetish. Her works of the 1970s are like icons of bondage, made with rope and metal. Mel Edwards's robust metal sculpture, *Nine Lynch Fragments,* is a metaphor of oppression. The works of Chase-Riboud and Edwards are related to those of other important American artists, such as Richard Lippold, David Smith, and Richard Stankiewicz. However, whereas the latter group made objects that articulated abstract spatial concepts, Chase-Riboud and Edwards, using the same welded steel, have evoked the legacy of the slaves in their work. Alma Thomas's work matured in the environment of the Washington color school, although she was never quite a part of it. Like the color school artists, Thomas made stained paintings. Like them she relied on flat shapes of contrasting colors, arranged in bands. Yet her abstractions recall the designs of African American quilts and African fabric. Thomas's fellow Washingtonian, Sam Gilliam, has been a more central part of the color school, from which his more recent work evolved (plate 1). He recognized the oneness of pigment and canvas and changed the concept of painting from creating an illusion of a three-dimensional object to the next logical step, which was the removal of the painting from the stretcher to create a free-standing object. Gilliam's art has expanded the scope of modernism to make the painting a cloth that itself becomes

an object moving through space, like a decorative African dance costume that takes on a spirit that belies its literal reality. William T. Williams has made abstract paintings with complex forms that have expanded the boundaries of both modernism and African American painting. Thomas, Gilliam, and Williams often use pattern to form part of their compositions, and their works show an affinity with African American quilts and weavings, African art, and the designs that decorate West African masks, African costumes, and African architecture.[8]

The work of all of these artists shows the historical dualism of African American culture. It is European in part, even as it is African. If the work of these artists seems to relate strongly to Eurocentric issues it is the result of both influence and coincidence. Influence, of course, because they studied among Europeans. But coincidence because the European tenets of art that they learned were merely the springboard for their exploration of African styles and themes of importance to African Americans. For example, Martin Puryear's work springs largely from Eurocentric sources, but is less traditional than those sources; and Adrian Piper's work contrasts Eurocentric sources with Afrocentric issues. But the art of people like Tanner, Hunt, Gilliam, and Williams explores cross-cultural commonalty by using Eurocentric styles and methods. In the final analysis, the issue is not how their work compares to that of their Euro-American peers, but how much it shows the artist's ability to create images that people from many cultures can relate to.

The Negro Speaks of Rivers

I've known rivers:
I've known rivers ancient as the world and older
 than the flow of human blood in human veins.

My soul has grown deep like the rivers.

I bathed in the Euphrates when dawns were young.

I built my hut near the Congo and it lulled me to sleep.

I looked upon the Nile and raised the pyramids above it.

I heard the singing of the Mississippi when Abe Lincoln
 went down to New Orleans, and I've seen its muddy
 bosom turn all golden in the sunset.

I've known rivers:

Ancient, dusky rivers.

My soul has grown deep like the rivers.

 Langston Hughes[9]

African American artists created their own formalism based on African culture. In the 1920s Langston Hughes in his poem, "The Negro Speaks of Rivers," looked back to ancient Egypt as the source of black people's culture. The importance of the African ancestral arts upon African Americans was most succinctly articulated by aesthetic philosopher Alain Locke. In a 1925 anthology of Harlem black writers called *The New Negro,* Locke wrote an essay called "The Legacy of the Ancestral Arts." In it he stated that an African American art could best be formed on the foundation of the African ancestral arts.[10] From then until now, many of the best African American artists have been affected by Locke's call. The paintings Aaron Douglas created between 1925 and the Great Depression exemplify Locke's ideas. In *More Stately Mansions,*[11] Douglas's figures appear in profile, a style that derives from the art of ancient Egypt, and his subjects are allegories of African American life. Jacob Lawrence

learned how to use the profile view Douglas pioneered as a way to depict his own experiences, events of African American history, and life during the Great Depression.[12]

Painting by the Egyptian formula of showing figures in profile in a flat space as Douglas and Lawrence had, helped to liberate African American art. Aaron Douglas began painting in the Egyptian manner, but that form freed him to explore local black American subjects. This style of painting gave artists a way to break the Eurocentric stronghold that had excluded expression about black life in art. But although they were allowed black subject matter, it had to be cloaked in an abstracted style that featured patterned, silhouetted figures. This was because the familiarity of the style to whites protected the new black subject matter from attack. As the abstracted style became freer, it became more important than the Egyptian style from which it had evolved. Artists became free to explore social issues. So it was that William H. Johnson, a highly trained Eurocentric artist, found through the flat Egyptian space a style for his folk paintings of the 1940s. The Langston Hughes poem, "The Negro Speaks of Rivers," echoes this process. It traces the history of African American culture from Egypt to the Mississippi in a tale told not through the lens of European history, but through the stories of African American folklore.

Nevertheless, art that is rooted in the African American experience has been around for a long time. Edmonia Lewis's late nineteenth-century sculpture, *Forever Free*, shows slaves breaking their bonds. *Forever Free* is a landmark in the expression of the psyche of the African American. So too is Augusta Savage's *Lift Every Voice and Sing*, a work that glorifies black voices and symbolizes group harmony, musically and politically.[13] Richmond Barthe made realist sculptures of black heroes, such as Frederick Douglass and Henri Christophe. Painter Archibald Motley explored social

satire and the role of cabaret in African American life. Motley's figures, with their exaggerated features and gestures, inhabit a world of fantasy. Charles White expressed the pain and sorrow of African American rural life in drawings and prints.

The arts of Africa continued to spark imaginations. Romare Bearden favored West African motifs, often alternating images of African masks and photographs of African American life in his collage. He tried to find the common ground of the black experience in Africa and in the United States. In the 1930s, Sergeant Johnson used West African and Egyptian styles to depict African American subjects. Elizabeth Catlett, who lives in Mexico, has transformed African forms such as Yoruba figures into African American and African Hispanic sculpture. Joyce Scott, working with nails, glass, and beads, makes African American versions of African fetishes and jewelry. Her work also shows the influence of Pre-Columbian art (plate 2). John Scott's sculpture is influenced by ancient Egyptian crafts, tools, the papyrus plant, and the pyramids. Raymond Saunders has spliced African urban scenes to images of urban life in America in all of its multicultural complexity (plate 3). Mildred Howard creates environments from her own cultural artifacts and from symbols of religious ceremonies and other events that have been meaningful to her (fig. 1.1).

A political agenda, created by some artists during the Civil Rights Movement, informs much of today's art. During the 1960s, public art, especially murals, gained momentum as a people's art.[14] Among the more prominent examples is the *The Wall of Respect,* created in Chicago, at 39th and Langley Streets, in 1967 (plates 4 and 5). It was one of many public murals painted in African American communities from Boston to Los Angeles. *The Wall of Respect* was a community venture, worked on by painters, photographers, printmakers, poets, including Eugene Eda, Bill Walker, Roy Lewis, Norman Parish, and Jeff Donaldson. They used images of Mohammed

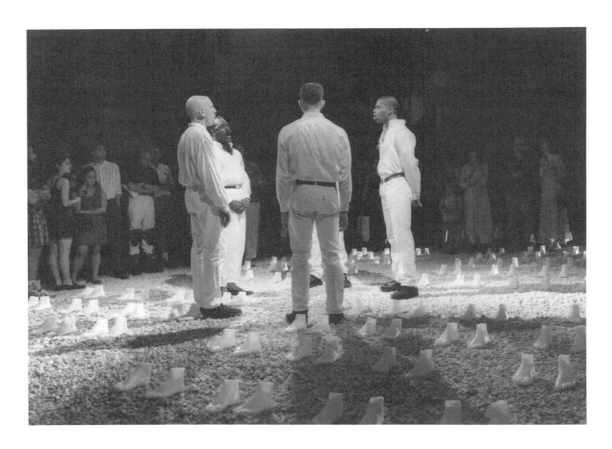

Figure 1.1.

Mildred Howard.
Walk with Me Children.
1992.
Mixed media installation
(gravel, molded wax).
Performance with gospel
singing group at "The
Anchorage." Creative
Time, New York.
Photograph by Marty
Heitner.

Ali, James Brown, Aretha Franklin, LeRoi Jones, Malcolm X, and Martin Luther King to make a collage. *The Wall of Respect* was significant because it was created by artists who shared a common political will. It represented no stylistic continuity or harmony, but, instead, a sociopolitical collective. The *Wall* made political and social ideology more important than formal concerns, an idea that was not to take hold in mainstream American art for many years to come. The iconography of the *Wall* was public in that everyone in the black community knew the meaning of all of its parts. Perceived by many whites as cliche-ridden imagery, in fact it was a successful attempt to use popular images to reach a broader audience. Many of today's white artists embrace this idea with no knowledge of its origin. *The Wall of Respect* established the concept of public art (art by fledgling artists that expresses the values of a wider public), as an alternative to private art in public places (personal art by established artists put on view in public places). Many examples of private art in public places, widely supported by our bastions of culture, including the National Endowment for the Arts, were built before that distinction became clear. In the light of today's proliferation of murals, where many artists work outside of the mainstream to generate a wider public, *The Wall of Respect* stands as a landmark in the evolution of contemporary American art.

Members of the Afri-Cobra movement, founded in Chicago in 1968, also aimed for a wider public. Founders included artists Jeff Donaldson, Napoleon Henderson, Nelson Stevens, Barbara Jones Hogu, Gerald Williams, Frank Smith, Wadsworth Jarrell. The goal of Afri-Cobra was to make an art that was accessible to all black people, and that expressed the political power of a black ideology. Afri-Cobra created posters because of the medium's low cost and ease of dissemination. They made art from magazine photographs of widely known heroes, such as Aretha Franklin, James Brown, Leroi Jones, Eldridge Clever, Malcolm X, and Martin Luther King.

Afri-Cobra (which continues to produce art), makes no distinction between aesthetic and political goals, a concept that today's postmodernists accept, but others denigrated in the 1960s.

African American artists have indicted American society and parodied their own reality. In the mid–1960s, Dan Chandler painted a number of works that condemned white America's treatment of African Americans. His *Fred Hampton's Door* is an icon of the Black Panther member who was murdered by the Chicago police.[15] David Hammons has made art from a variety of vernacular African American images to satirize white America's interpretation of black culture. His mural *How Ya Like Me Now?*[16] portrays Jesse Jackson as a white man. Bettye Saar has created many African American shrines and has explored the socioreligious mythology of black people. Saar, Chandler, and Murray DePillars are among the African American artists who have used themes such as Aunt Jemima, Uncle Ben, Black Sambo, and watermelons to satirize black images that are sacred to white America but insulting to black people.

Artists have also explored the indigenous experience through arts that have a wider public appeal: the blues, jazz, rap, reggae, photojournalism, the movies, and TV. Author Ralph Ellison is supposed to have said that all the paintings of Jacob Lawrence, Romare Bearden, and Norman Lewis don't add up to the power of one musical note by Charlie Parker. The statement, even if apocryphal, points to the relatively small impact of painting and sculpture on African Americans. The difficulty to ignite the passion of black audiences has been a historical monkey on the back of black artists. Can art by black people turn on black folks like their music? Does it have the intrinsic capability to reach the soul of black folks? Do the painting on the wall and the statue on the pedestal—traditional European constructs—have the same importance to blacks as they do to whites?

Photography and filmmaking have appealed to a wider audience, black and white alike. Perhaps because these are newer media, with shorter traditions, they are less culturally bound than are painting and sculpture. Their language and codes have been accessible to all people, irrespective of culture or race. The photography of James Van Der Zee, Roy DeCordova, and Gordon Parks has attracted a wider black audience. Noting the effectiveness of photography, other artists incorporated it into their work to achieve a wider audience. The artists who created *The Wall of Respect* and the members of Afri-Cobra used photographs as mass consumer imagery. Gordon Parks filmed the *Shaft* movies and showed a generation of black photographers new possibilities of lighting and color.

Filmmakers and actors such as Melvin Van Peebles, Sidney Poitier, and Harry Belafonte explored black humor in film and in turn fueled the creative spirit of a new generation of black film and TV makers. Spike Lee, John Singleton, Mario Van Peebles, and Bill Cosby have plunged into popular culture where they have found that black folks are ready to break down the boundary between art and entertainment. By combining these categories, black artists have created a new popular art. The new art finds the soul of black folk in the spontaneous social mixture of the street, which creates a new dynamism. It is not crime they find there, but passion, which is free. Artists Carrie Mae Weems and Pat Ward Williams work with photography, narrative, and installation, and draw their content from personal experience, history, and the hip life of the streets. Philip Mallory Jones's video deals with African American popular issues. Langston Hughes said that black culture was in the lives of the down-home folk. Miles Davis searched for new pop melodies as a source for his jazz. When asked where jazz improvisation would end, Dizzy Gillespie supposedly said it would end where it had begun: with a man beating a drum. He meant that the essence of African American art was in its primal impetus, which is self-definition.

In the 1960s, artists learned that they are freed artistically more by political power than by any aesthetic development. During that decade, the white establishment gave black artists more play than ever before, not because the art had suddenly become better, but because they were afraid of black power. In the 1980s they stopped because they were no longer afraid. Today some artists empower themselves by creating a market (for example, filmmakers and pop musicians), and by making new alliances with black artists across the globe. The work of recent African American artists is not better than that of their predecessors, but it is freer. It is freer from Eurocentrist, as much as from ancient African art, even when it includes both. By declaring that there is no difference in quality between "high art" and entertainment, they have revealed that, at least for them, "profundity" is no more than a chimera, and "quality" no more than a cultural bias. How much like the postmodernists does this sound! But whose authorship is it? African Americans! What a great debt postmodernism owes to African American ideas!

African Americans have joined a larger matrix of pan-African artists: people of African descent from many countries who now live in America. No longer is there just African American art, but a global presence of black artists in the United States. In the 1920s, Alain Locke called for artists to study the ancestral arts. He had traveled to Africa, collected African art, and wrote extensively on the subject. His vision of Africa was for a reunification of African peoples the world over.

James A. Porter shared Locke's views. From the 1940s through the early 1960s, Professor Porter, artist, writer, curator, brought many black artists from around the world to the United States, where he arranged exhibitions for them at the Howard University Art Gallery. Among the ones he brought were Brazil's Candido Portinari, Cuba's Wifredo Lam, Haiti's Wilson Bigaud, Nigeria's Ben Enwomwu. Porter traveled extensively in Africa, South America, and the Caribbean, researching the work

of artists of African descent and writing about them. In 1951 he arranged the first exhibition of contemporary African art ever held in the United States, at the Howard University Art Gallery. Porter and his predecessor James Herring showed many white artists too (such as Morris Louis, Gene Davis, Kenneth Noland, David Smith). Their idea was to provide not only wider exposure for an international group of black artists, but to show that white artists could be integrated into an African-centered pantheon.

More recently, David Driskell has written on the influence of African ancestral art and has curated pan-African art exhibitions, such as *Introspectives: Contemporary Art by Americans and Brazilians of African Descent.*[17] In the 1970s, Mary Schmidt Campbell, then director of the Studio Museum in Harlem, exhibited contemporary African artists together with African American artists. Her successor, Kinshasa Holman Conwill, has expanded the tradition to include art by people of color from several nations. In Los Angeles, Dr. Samella Lewis has pioneered in curating exhibitions that show relationships among African Americans, Caribbean people, South Americans, and Africans. Video artist Philip Mallory Jones curated the first globally touring collection of video art by African diaspora artists in the summer of 1994.[18]

Over the last twenty-five years, many white scholars have joined the cause of promoting artists of African descent. The National Museum of African Art in Washington, D.C., was founded by Warren Robbins. A part of Robbins's philosophy was to show the relationship between the African ancestral arts and contemporary art by Africans and people of African descent worldwide.[19] Equally significant is scholar Robert Farris Thompson. In his books and exhibitions, such as *African Art in Motion* and *Flash of the Spirit,* he has created a distinction between a true understanding of African art and the European perception of it as static anthropological icons. He

has explored the concept of African art as a part of life and as a continuing presence in contemporary art in many exhibitions, lectures, and publications. Others such as Susan Vogel, director of the Museum for African Art in New York, John Nunley, Marilyn Houlberg, Judith Bettleheim, and the late Jean Kennedy-Wolford have revealed relationships between African art of the past and of today in various parts of the world.

Formalism has been the driving force in the evolution of modern art, but it has been far less of a preoccupation among African Americans than among whites.[20] Perhaps this is because African Americans, having been kept outside the mainstream, searched for other ways to express themselves, and many of them dissolved the boundary between formal and folk art. These artists often work outside of Western pictorial traditions and improvised the style of their work to portray the black experience. William Edmundson, Sargent Johnston, William H. Johnson, Horace Pippin, and Minnie Evans are African American artists from the 1940s whose works are among the earliest examples of this movement. Edmundson, Pippin, and Evans were called "primitive." Johnson and Johnston were formally trained artists, yet their mature styles have a directness often associated with folk art. They depicted some of the legends handed down by the slaves and the subjects of the spirituals. In African American art, trained and untrained artists often work in similar styles. The greater number of recognized American primitives are African American.[21]

Contemporary artists such as Faith Ringgold, David Hammons, Lois Mailou Jones, Bettye Saar, Alison Saar, Frederick Brown have all bent the boundary between formal and informal art. Ringgold has made a large number of quilts that are decorated to reflect the themes of the spirituals. Martin Puryear's handcrafted sculptures have biomorphic shapes and organic materials that mirror the world of nature. Performance artists Greg Leigon[22] and Sherman Fleming focus on the black experience.

Fleming describes his performances as combining "childhood games, ritual dance actions, and quotidian gestures" within a "social matrix of racism and sexism"[23] (fig. 1.2). Cuban Wifredo Lam forged a style from cubism and surrealism, but his subjects come from African experiences. Quattara from the Ivory Coast places images of African figures, symbols, and architecture in a two-dimensional space (fig. 1.3). Haiti's Rignaud Benoit explores African Caribbean myths and folklore. Edouard Duval-Carrié's art combines primordial forms, African Caribbean ritual, and references to postcolonial politics (plate 6). Jamaica's Kapo, who was a priest, created paintings and sculptures of figures that became icons of his African Caribbean religion. Maren Hassinger's environmental installations reveal her ability to merge designs from African architecture and hatchery into abstract art.

Like the fallen boundary between high art and popular entertainment, the collapse of the boundary between formal art and folk art has far-reaching implications. For African Americans, it furthers the cause of artistic equality. In the 1960s, Bob Thompson reinterpreted the principles of Renaissance art in ways that made people think of his work as "primitive." He broke down the division between formal art and folk art by combining elements of both. David Hammons uses objects he finds among black people, such as bottle caps and barbershop hair, as emblems of black culture. Critic Judith Wilson feels that Hammons's art is based on "radical egalitarianism. . . . [He is] disenchanted with Western materials."[24] Bettye Saar makes icons of found objects. Robert Colescott parodies formal art by substituting cartoon figures for classical heroes.

Other artists draw inspiration from the art of Africa. Emma Amos borders some of her paintings with Kente cloth. Faith Ringgold and Howardena Pindell explore their own biographies through quilts, beadwork, and sewn fabric. Martha Jackson-Jarvis uses ceramics to make sculpture that is reminiscent of ancient African artifacts

Figure 1.2.

Sherman Fleming.
Pretending to be Rock.
1993–1994.
Performance piece.
Photograph by David
Simonton.

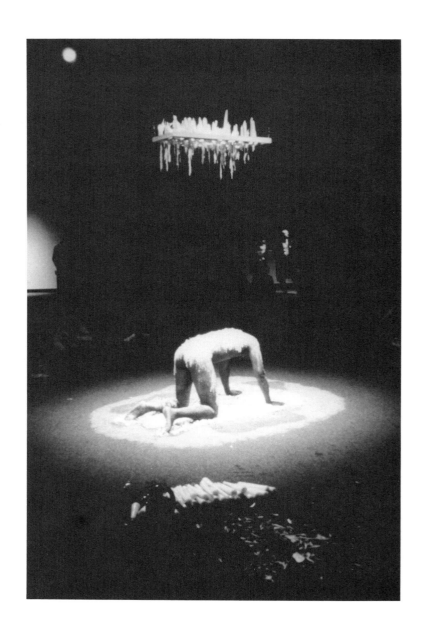

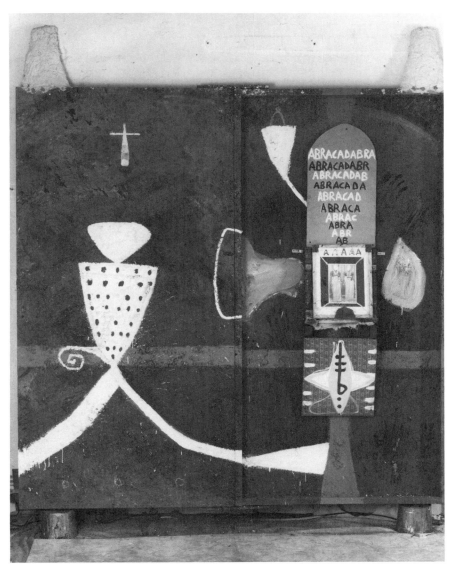

Figure 1.3.

Quattara.
Gaia. 1994.
Mixed media on wood.
University Art Museum,
University of California
at Berkeley. Gift of the
artist.

recently unearthed or pulled from the bottom of the sea. Joyce Scott uses beads, metal armature, and found objects to create a mythology through imaginative artifacts that appear to come from ancient Africa through the era of slavery. Adrian Piper uses verbal expressions, advertising, and photojournalism to examine stereotypes about people of color.

The recent immigration of millions has brought into the United States the greatest confluence of the African diaspora in history. Immigration is changing the definition of what it means to be an African American. Artists Skunder Boghossian (Ethiopia), Quattara (Ivory Coast), Juan Sanchez (Puerto Rico), and Kofi Kiyaga (Jamaica) live and work here, as do thousands of others. African artists Twins Seven-Seven and Lamedi Fakeye show and lecture across the country. The United States Information Agency's international programs bring us artists from Haiti and South Africa. African and African American art journals are sharing information to a dramatic degree. A number of these people of African descent are inclined to combine the visual arts with music, dance, and ceremony. Yoruba practices, African altars, Caribbean ceremonies, and African Brazilian customs have become common from New York to Oakland. The exhibition and book *Caribbean Festival Art,* curated and written by Judith Bettelheim and John Nunley, explored the history of the festival and its origin among Africans in the Caribbean and the spread of its popularity to the United States and Canada.[25] In Chicago, Mr. Imagination creates African American figures from bottle caps, wood, and nails that look like African icons (fig. 1.4). Also in Chicago, David Philpot, a self-trained artist, makes West African style canes that he decorates with snakes and other symbols of magical potency.

Artists of African descent all over the country are exploring shrines and altars. Renée Stout from Washington, D.C., creates slave-like environments and shrines that evoke the spirits of her African ancestors. Robert Farris Thompson's exhibition, *Face*

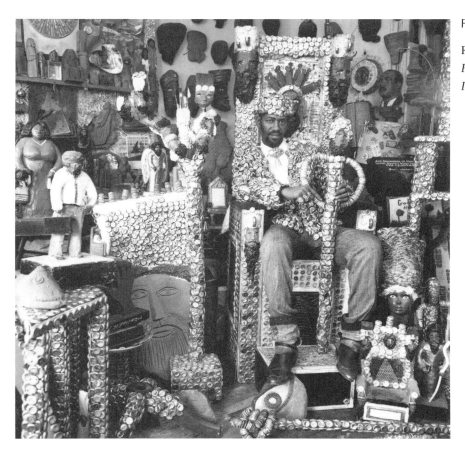

Figure 1.4.

Ron Gordon.
*Portrait of Mr.
Imagination.* 1991.

of the Gods,[26] presented 18 altars that linked West and Central African religious art to that of Brazil, Cuba, Haiti, Puerto Rico, and to peoples of African descent in North, Central, and South America (fig. 1.5). His work is shown in New York as well as Haiti. Among his works recently shown in museums is an African Brazilian altar to the Yoruba creator god. Judith Bettelheim's view on this installation sheds light on an important aspect of the new pan-African art:

> How does one maintain belief in the face of centuries of suppression? How does one practice religion in the face of legal strictures against it? It must be realized that the practice of noninstitutionalized religion in America is/was in and of itself a revolutionary activity. It is often difficult for those of us educated in a European "avant-garde" tradition to view religious belief and expression as revolutionary, but in fact that is what developed in the Americas when the descendants of Africans creatively developed and practiced new religions under slavery and colonial repression. Some would even insist that, in some locations today, the contemporary practice of noninstitutionalized religions continues to be a rebellious, if not revolutionary, activity. And in some locations the practice of any religion is/was regarded as subversive. It is within this context that the altars included in this exhibition must be appreciated.
>
> Sequins, lace, a faux leopard skin, doilies sprayed with gold paint, a quilted baby blanket, tops of feather dusters . . . strips of wooden beads from the seat covers that New York taxi drivers use, cement poured into sculptural forms, plastic flowers . . . objects that have been disassembled and reassembled to create installations crafted by the hands of practitioners, believers, survivors.[27]

Historians Thompson, Vogel, Robbins, Bettelheim, Nunley, Houlberg, and Drewal join the family of the diaspora in the United States. Pan-Africanism is more than a concept of race; it is the collective celebration of African culture the world over by

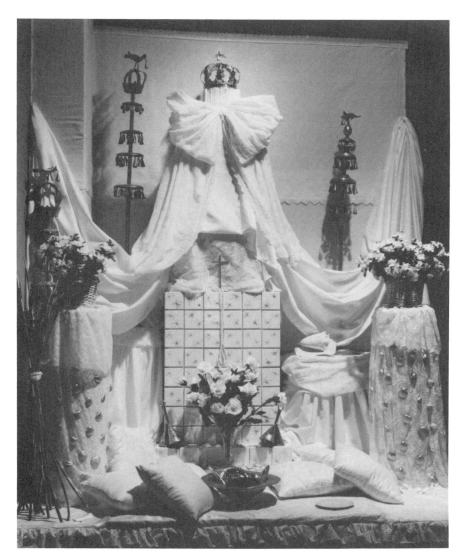

Figure 1.5.

Oju Oxala: Afro-Brazilian Altar to the Yoruba Creator God. Based on an altar made by Mai Jocelinha in Salvador, Bahia, Brazil. Summer 1982. Mounted by Enedia Assunção Sanches. Courtesy of the Museum for African Art, New York. Photograph by Jerry L. Thompson.

black people especially, but also by others who are dedicated to the African experience. Celebration of pan-African ideas also comes from artists of other color, such as Vietnamese American Trinh T. Minh-ha, who worked in Africa and whose films and writings reflect the African sensibility. Christine Choi makes documentaries in Africa, New York, and Los Angeles about issues that are of importance to blacks. African Americans and their adopted brethren are linked across continents less by postmodernism than by a common pan-African experience.

In this collective, seemingly disparate people share three things: They are intrigued by issues of color (not necessarily their own), they are inspired by the African legacy, and they are committed to the art of the outsider. The source of their interest is the excitement created by the recent arrival of blacks from South America, the Caribbean, Africa, and Asia, who bring their various hues and cultural allegiances with them. The bond of these people of color seems to be Africa, not only because many share this legacy, but because African Americans have paved a path for universal cultural redemption through their telling of the African story. A Chinese American artist told me that a group of his people, after months of trying to define a strategy for their own cultural redemption, came to recognize that the best one was the strategy of the African American artists of the 1960s. Organizations of women artists (who have been mostly white) were among the first to take much of their rhetoric from African American artists.

Yet whatever their origin or gender, as they meld and join political common cause under the ever-widening umbrella of "people of color," white artists seem to be moving inexorably away from the old American polemic of black versus white. Americans are beginning to see themselves as people of different hues and ethnic groups.[28] The old racial labels of black, white, and yellow don't seem to stick anymore. Color is becoming a descriptive term: an adjective to describe differences in

hue, rather than a noun to describe a race. As color distinctions proliferate, white may become not a race apart, but another color among many. But will this eliminate racism in America? The likely answer is no, since without a massive redistribution of wealth (not to happen soon) people of color will remain the poorest. By virtue of being poor—and disenfranchised—artists of color likely will continue to work outside of the art establishment for the foreseeable future. The driving force, then, of much American art inevitably may become African American ideas, albeit by misfortune. "African American" may become a political term rather than a racial one. "White" should also be a political term since there is no scientific way to establish whiteness by looking at someone.[29]

A major difference between African American and Euro-American artists is that the former know their politics is racial, while the latter claim that their politics is economical.[30] Although the two propositions are not mutually exclusive, the African American one gets specifically to the heart of the downtrodden, who believe that poverty is not the cause of racial bias but the result. African American art proponents establish their case by the evidence of the relationship between their color and their disenfranchisement. To the many who are inspired by African American art, be they people of color from Ghana, India, Korea, or Brazil—or be they white women or white men—the reason for their empathy is not the African blood that may or may not flow in their veins, nor is it their love of black people, to whom they may be indifferent, but it is the heroic example of the African American art that serves as a symbol of indomitable will to construct cultural survival in the face of seemingly insurmountable odds. That is the gift of African American art to the future. This is its postmodernist beacon.

Notes

1. Judith Wilson, "Seventies into Eighties: Neo-Hoodism vs. Postmodernism," *The Decade Show* (New York: New Museum of Contemporary Art, 1990), 130–31.

2. Thomas McEvilley, *Fusion: West African Artists at the Venice Biennale* (New York: Museum for African Art, 1993).

3. Race has been the defining factor among people throughout American history. The nation's first statute to establish requirements for citizenship, passed in 1790, limited naturalization to "aliens being free white persons." Although amended to grant citizenship to blacks during the Civil War, the law stood until 1952. Many nonwhites, including Indians and Japanese, found it necessary to try to prove they were white until 1952.

4. The definition of black was not always specific. For example in the nineteenth century, free mulattos were not considered black. Before the Civil War, several Southern states allowed people of mixed black and white ancestry to define themselves. After the Civil War, Southern whites passed laws that lowered and ultimately decreased to zero the percentage of black blood a white person could have. By 1924 legislators in Virginia prohibited whites from marrying anyone with "a single drop of Negro blood." Other states in the South as well as the North followed suit.

5. Henry Tanner (1859–1937). Other early African American artists such as Edmonia Lewis (1845– ca. 1890) and Augusta Savage (1892–1962), will be discussed later.

6. Richard Hunt has long been a collector of West African metal works and sculpture.

7. Barbara Chase-Riboud has been active since the late 1950s. Today she works in the United States and France.

8. Even before the abolition of slavery, the United States government had made plans to return blacks to Africa. After abolition, blacks returned to Africa, especially to Liberia, which was founded by African Americans. The concept of Africa as the original center of black American culture had been explored by many earlier artists, but interest reached a peak in the 1920s.

9. See Keith Morrison, "Art Criticism: A Pan-African Point of View," *New Art Examiner* 6, no. 5 (January 1979): 4–7.

10. Alain Leroy Locke (1896–1954) was a Harvard graduate and the first black Rhodes Scholar. He became a professor of aesthetics and philosophy at Howard University. He was also the editor of *Crisis* magazine, published by the NAACP, and was the most respected black critic of the 1920s and 1930s. In the *Crisis*, Locke wrote an essay entitled "The New Negro" in which he called upon black artists and intellectuals to embrace the principles of

the African ancestral arts as a basis for an African American cultural ideology.

11. *More Stately Mansions* is a mural that Douglas painted in the Harlem branch of the New York Public Library.

12. Jacob Lawrence has said that he did not consciously imitate the flat space of Egyptian art because he taught himself how to paint, and he defined space according to a personal system. Nevertheless, his teacher at the Harlem Workshop, Charles Alston, knew of the theories of Locke and Douglas.

13. The work takes its name from the so-called black national anthem written by James Weldon Johnson.

14. For a good overview of the period, see Eva Cockcroft, John Weber, and James Cockcroft, *Toward a People's Art* (New York: E. P. Dutton, 1977).

15. Fred Hampton, a member of the Black Panther Party, and others were murdered in their sleep by gunfire from Chicago police.

16. Created in 1988 as a commission for *The Blues Aesthetic* (Washington Project for the Arts, Washington, D.C.) this painting was controversial among some African Americans who misunderstood its ironic intent.

17. Henry Drewal and David C. Driskell, *Introspectives: Contemporary Art by Americans and Brazilians of African Descent* (Los Angeles: California Afro-American Museum, 1989).

18. Philip Mallory Jones's touring exhibition of video traveled from California to New York City, Havana, Rio, London, Paris, Berlin, Nairobi, Dakar, Abidjan, and Ouagadougou.

19. Robbins turned the museum over to the Smithsonian in 1979. The Smithsonian lost sight of Robbins's desire to show such relationships when it took over the African museum and relegated the African American portion of the collection to the Museum of American Art. Only in the last two years has the Museum of African Art begun to exhibit art by contemporary African artists. As one African artist asked: "Why does European history continue today, while mine is thought to have died in the nineteenth century?"

20. It has never been all-pervasive, since modernist artists such as Ben Shahn, Joseph Cornell, Leon Golub, Harry Westerman, Julius Schmidt, and Roger Brown developed non-formalist art, as have a range of funk artists and groups such as the "Hairy Who," but they have been additions—albeit important ones—to the mainstream of modern American art, rather than the driving forces behind it. Others such as Grandma Moses, Edward Hicks, and John Kane, all called "primitive," have, of course, been important in American art.

21. This fact has been documented by several books and exhibitions on the subject. African American artists such as Horace Pippin, Sister Gertrude Morgan, James Hampton, Joseph Yoakum, and William Edmundson are only a few of the many recognized primitives in American art.

22. Greg Leigon is one of a growing number of artists who are exploring aspects of gay culture in black America.

23. Sherman Fleming, who has made art individually and with groups over the years, performs under the names RODFORCE and Generator Exchange.

24. Wilson, "Seventies into Eighties," 133.

25. Judith Bettelheim and John Nunley, *Caribbean Festival Art* (Seattle: St. Louis Art Museum and University of Washington Press, 1988).

26. Robert Farris Thompson, *Face of the Gods: Art* (Munich and New York: Prestel and the Museum for African Art, 1993).

27. Judith Bettelheim, "Face of the Gods," *Art Journal* 53, no. 2 (summer 1994): 100.

28. According to the 1990 census, Americans claimed membership in nearly 300 races or ethnic groups and 600 Native American tribes.

29. Tom Morganthau,"What Color Is Black?" *Newsweek* 125, no. 7 (February 13, 1995): 62–72. Morganthau states that race has practically no meaning in terms of color. According to scientists quoted in the article, the dark-skinned Somalis, for example, are no more related genetically to the Ghanaians than they are to the Greeks. Some scientists point out that the notion and specifics of race predate genetics, evolutionary biology, and the science of human origin.

30. I am not prepared to argue the Euro-American case.

Bibliography

Bettelheim, Judith, and John Nunley. *Caribbean Festival Art*. Seattle: St. Louis Art Museum and University of Washington Press, 1988.

Bettelheim, Judith. "Face of the Gods." *Art Journal* 53, no. 2 (summer 1994): 100.

Campbell, Mary Schmidt, David Driskell, and Cedric Dover. *American Negro Art*. New York: New York Graphic Society, 1960.

Cervantes, Miguel. *Mito y Magia en America: Los Ochentos*. Monterey, Mexico: Museum of Modern Art, 1991.

Cockcroft, Eve, John Weber, and James Cockcroft. *Toward a People's Art*. New York: E. P. Dutton, 1977.

Debela, Acha, and Kenneth Rogers. *Afri-Cobra*. Eastern Shore, Md.: Mosley Gallery of Art, University of Maryland, 1984.

Drewal, Henry, and David C. Driskell. *Introspective: Contemporary Art by Americans and Brazilians of African Descent*. Los Angeles: California Afro-American Museum, 1989.

Dyson, Michael. *Reflecting Black*. Minneapolis, Minn.: University of Minnesota Press, 1993.

Kennedy, Jean. *New Currents, Ancient Rivers*. Washington, D.C.: Smithsonian Institution Press, 1992.

Lewis, David Levering, and Deborah Willis Ryan. *Harlem Renaissance: Art of Black America*. New York: Studio Museum in Harlem and Harry N. Abrams, 1987.

Lippard, Lucy. *Mixed Blessings: New Art in a Multicultural America*. New York: Pantheon Books, 1990.

McEvilley, Thomas. *Fusion: West African Artists at the Venice Biennale*. New York: Museum for African Art, 1993.

Morganthau, Tom. "What Color Is Black?" *Newsweek* 125, no. 7 (February 13, 1995): 62–72.

Morrison, Keith. "Art Criticism: A Pan-African Point of View." *New Art Examiner* 6 (January 1979): 4–7.

New Museum of Contemporary Art, Museum of Contemporary Hispanic Art, and Studio Museum in Harlem. *Decade Show: Frameworks for Identity in the 1980s*. New Museum of Contemporary Art, Museum of Contemporary Hispanic Art, and Studio Museum in Harlem, 1990.

Porter, James A. *Modern Negro Art*. 1943. Reprint, Washington, D.C.: Howard University Press, 1992.

Powell, Richard. *The Blues Aesthetic*. Washington, D.C.: Washington Project for the Arts, 1989.

Thompson, Robert Farris. *Face of the Gods: Art*. Munich and New York: Prestel and Museum for African Art, 1993.

2

Living Fearlessly with and within Difference(s)

Emma Amos, Carol Ann Carter, and Martha Jackson-Jarvis

SHARON PATTON

⊞⦂▤⊞ The African American woman as visual artist must negotiate and determine her location within postmodernism. Three such artists, Emma Amos, Carol Ann Carter, and Martha Jackson-Jarvis, confront and delve into the legacy of modernism and modernity. They reveal the complexity of being black within white society and living W. E. B. DuBois's "double consciousness." In addition they show how being black conflates with gender. By examining their strategies and cultural politics, one can discover how they address gender and racial otherness, as well as essentialized blackness.[1] These artists implode the old and revisionist canons because their art proposes theoretical models that can explain black art as a part of African American culture and, heretofore unacknowledged, as American art history. Consequently, challenges

arise when critics and art historians try to decipher their works' imagery and meaning as postmodernist art.

The old canon is modernism; the new is postmodernism. As Hal Foster succinctly noted,

> Postmodernism is often a mere sign for not-modernism or a synonym for pluralism. What postmodernism is, of course, depends largely on what modernism is, i.e., how it is defined. As a chronological term, it is often restricted to the period 1860–1930 or thereabouts, though many extend it to postwar art or "late" modernism. As an epistemological term, modernism is harder to specify.[2]

Postmodernism lacks a single inclusive definition based on consensus by scholars. The literature confirms only two constants: that there are shifts in meaning and denotation, and that postmodernism, like modernism, has no single style. The current debate about postmodernism is a shift in modernism's program or ideology, a search for aesthetic purity, universality, or some greater truth rather than any particular style or technique. Postmodernism is about theory and practice, objects and their meaning.[3]

Theory and art production transform art into textual image. The visual becomes a sign, a referent to the historical moment of its production. Painting and sculpture are like artifacts, primary source material from which one extrapolates meaning and significance about culture and society. In the visual arts, postmodernism may denote pre-late modernism as articulated by critic and philosopher Clement Greenberg. Or it may denote theory foreground to practice. Regardless, in opposition to modernism, art assumes critical significance. In its radical configuration, postmodernism ultimately is about power and knowledge. Institutions and the canonical traditions of

art history—practice, theory, and criticism—are examined and critiqued. There are challenges to the status quo, to art history. As an antithetical response, postmodernism promotes popular culture; nontraditional fine art media, narrative, intertextuality, impurity of form and aesthetics, bricolage; symbolism and metaphor. It debunks claims of avant-gardism and innovation, and the concept of the artist as individual master.

Most importantly, as cultural politics, postmodernism stresses theoretical discourse that sees

> the forms and occasions of representations as in themselves power (rather than merely the reflection of power-relations that exist elsewhere), and that power is best understood in the micro-political terms of the networks of power-relations subsisting at every point in a society.[4]

Three artists, Emma Amos, Carol Ann Carter, and Martha Jackson-Jarvis, use discursive and deconstructive strategies familiar to postmodernist theorists. Their most recent works reveal a desire to destabilize and displace power as represented by dominant culture, translated as white, patriarchal, and Eurocentric. Art as representation becomes a tool to evaluate and assess the validity of prescribed Western artistic canons. Amos's, Carter's, and Jackson-Jarvis's mixed-media works challenge presumptions about the purpose and nature of art.

John Roberts remarks that such deconstructive practices

> seek to link a critique of "dominant representation" to a critique of representation *as such*. Thus the political function of art is principally to show how claims to represent the "truth" and the "real" as either partial and/or ideologically motivated. This

"deconstructive" type of postmodernism is rooted first and foremost in feminism's critique of representation as a pure and unitary system of reference. "Radical" post-modernism has made its break with modernism not simply in terms of a *return* to the political referent but in terms of the questioning of the power relations that govern the production and reception of the visual itself. Essentially radical postmodernism is a critique of modernism as a canon and history of Western male authorship.[5]

Two types of protagonists perform in this postmodernist arena. One is the artist who owns artistic production and translates the postmodernist condition. The other is the critic, the cultural and art historian, and the institution that interpret the art and artists.

Theories about alterity enable artists, critics, and curators to engage in a discourse about difference and promote the inclusion of different cultural and gender voices marking different and shifting identities. Critiques about difference foster cultural hybridity and ostensibly privilege postmodernism as a means to locate the "authentic other," those silent, invisible artists outside the mainstream: women and racial and ethnic minorities, the politically disfranchised.[6] Western European or Euro-American theoretical paradigms and art practices frequently omit African Americans as evidenced in the literature, especially art history. By including some and excluding others, postmodernism sustains modernism's binaries of "center" and "margin."

Where, then, and how does the African American woman artist locate herself within postmodernism? How does she present her views about power and, through art, highlight the dialogic relationship with the viewer about oppression, repression, blackness, and femaleness within the constricting parameters of modernism out of which develops postmodernism? Because it can articulate meaning about class, race,

and gender, art is consequential. Again, at the core is cultural politics. Who is empowered; who speaks for whom?

Emma Amos, Carol Ann Carter, and Martha Jackson-Jarvis produce art that signifies who they are as others define them and how they define themselves. By claiming authorship, they reverse their traditional role as the subject of discourse. The signified becomes the signifier. They become empowered. The dismantling of canonical traditions, the exploration of issues and ideologies about race and gender in the transatlantic black and white cultures, and the superimposing of their personal experiences are used to enlighten the viewer. In the process, reinforced by their own mere existence, Amos, Carter, and Jackson-Jarvis invariably critique and contest modernism: institutions (museums, academies), and art practices (painting and sculpture as male-centered and European), as well as the postmodernist's belief in the impossibility of innovation and ahistoricism.[7] Their mixed-media paintings, sculptures, and room environments act as signs for the postmodernist condition.

Emma Amos, Carol Ann Carter, and Martha Jackson-Jarvis create a female *and* black matrix within which power is inscribed and acquired. Empowerment is achieved by creating an alternative framework for organizing a text about female and black subjectivity. Contrary to popular views about the black female, she is not "physically or mentally subject to someone else by control and dependence," but tied "to one's own identity by a consciousness or self-knowledge."[8]

Through art that is essentially representational, these three women artists promote innovation and revisionist aesthetics. They promote these concepts either through the work's subject matter—the image termed by postmodernist cultural historians as "textual production." Or they use process, technique, and aesthetic principles, which when considered within a sociohistorical context are "visualizations of

social practice and forces"[9] that often function as metaphor or allegory. As representation, the former may be inseparable from the latter, as is most evident in the art of Carol Ann Carter and Martha Jackson-Jarvis.

Emma Amos's most recent mixed-media paintings and prints were exhibited in *Changing the Subject* (1994). Like her earlier paintings, the overall backdrop for her idiosyncratic imagery is abstract expressionist. The inimical marks are there: gestural notations of the brush and broad flat areas of color punctuated by drips and splatters and filaments of paint. Illusionistic painted images or laser transfer photographs are superimposed on this expressionistic backdrop in *Equals* (fig. 2.1). Alongside patterned shapes, objects, portraits, are strips of textiles and, added recently, larger pieces of cloth and flags. West African traditional narrow-strip weavings from Ghana, (Adinkra, Kente), Burkino Faso, and Mali, and popular modern, machine-made cloths (wax and roller prints) have parity with paint. Textiles form collage paintings; asymmetrical cloth borders and polyrhythmic patterns and colors suggest a patchwork quilt. The visual focus usually is on one or several foreshortened, suspended, illuminated figure(s), often self-portraits of Emma Amos (fig. 2.1). Figures and objects highlighted against vortexes of movement, spatial chasms, and fathomless space tumble or soar, and seem to move in the opposite direction of the expressionistic color-field background. Subsidiary images, figures, animals, and objects such as a wall, house, stars exist in the interspace between figures and an ambiguous other-place, background/below ground, or void.

But these most recent paintings are not merely restatements of the modernist aesthetic canon. They are both psychological self-portraits and historical narratives, and this becomes particularly clear when they are exhibited as a group as they were in *Changing the Subject*. Figurative images comprise the essential subject matter of Amos's work. They, along with other motifs, are symbolic, allegorical clues. Figures

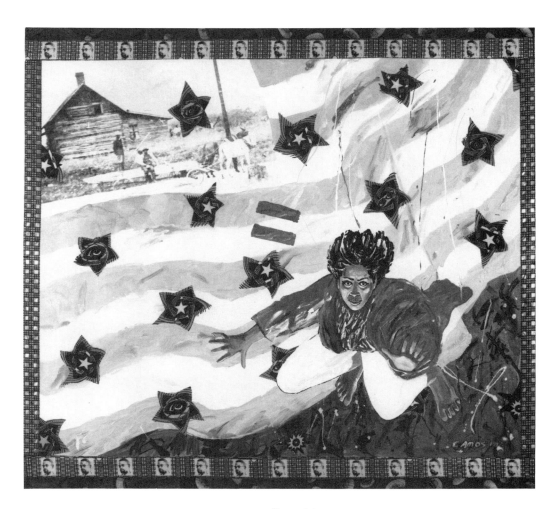

Figure 2.1.

Emma Amos.
Equals. 1992.
Acrylic on canvas,
fabric, laser transfer.

76 × 82 in.
Collection of the artist.

convey psychological and sociological conditions, especially freedom, entrapment, victimization, fragility, phobias, and insignificance. And they convey critiques of Western racial prerogatives of cultural appropriation and the objectification of black sexuality; of economic, social, and gender disempowerment. Images adrift in open spaces are like comments punctuating silence.

Mixed-media paintings such as these are also postmodernist statements about cultural reclamation. Assuming agency, Amos appropriates a signifier of black culture, African cloth that has become, in contemporary American society, popular art or "kitsch," but inverts "kitsch" into a valued sign.[10]

The textile borders of Amos's recent works suggest cultural boundaries or marginality. African fabrics represent the diaspora, or precolonial and colonial Africa and its pivotal role in the development of modernism. Perhaps unwittingly, Amos plays text upon text because the names of the African cloth patterns denote a proverb, political slogan, or cultural context enhancing the themes of her works. For example, an Akan mourning cloth called Adinkra frames *Way To Go Carl, Baby* (1992), a memorial to deceased artist Ana Mendieta and an indictment of her mate, sculptor Carl Andre. Political overtones are suggested by the popular African cloth that shows images of Malcolm X framing black stars symbolizing pan-Africanism (Marcus Garvey and the Black Star Line of Garvey and Ghana, West Africa); or the image of a black sharecropper that replaces the field of stars in the American flag in *Equals*. Dispersed, isolated visual images in African cloth and the painted canvas force the viewer to find meaning in the connection between the periphery and the center.

Amos's figurative paintings are narratives about race, racialism, and racism. With painted Xs she symbolically edits historical narrative, expunges white male dominance as racialist and sexist, and marks her opposition to racism in *Which Way*

Is Up George Baseless (1992), *Stand Out* (1993), and *X-Flag* (1994). Cryptic Xs mark views about the Eurocentric cultural construction of gender and race, which for Amos represent "how hardly anyone gives a damn what I say." X denotes invisibility or absence within American historical narrative where preeminence of authorship and the predominant exclusion of non-Europeans are uncontested. Amos rewrites the text. She inserts her own narrative, whereby she coopts white privilege, engages in a dialogue about power and the absence of it, yet purposefully avoids acting as the spokesperson for black people.

Figures adrift are allegories about victims of economic and social oppression, their spiral tumbling succinctly conveys societal displacement. For Amos, her self-portraits convey what it is like being black and a woman in that same world. Inevitably there are historical allusions to colonialism, the uprooting and transposition of a people from one place to another, the transgression of cultures, maintaining the status quo by socioeconomic dominance as seen in the laser photograph of a Southern shack in *Equals*.

Her titles explain the meaning of the "text." For example, "equals" denotes "separate but . . ." or "all men are created . . . ," the irony between the political ideology and the social condition is exposed. In *Equals*, a photograph (a gift from her uncle) dated ca. 1930 of blacks in Mississippi or Tennessee evokes memories. "I look at that black man in his 70s, he would have been a slave; the separation from slavery and today reminds us it was not too long ago; and the young man if he is still alive would realize that this time equals that time [that the social and political conditions of blacks remain virtually unchanged]. What are the differences?" This question is clearly represented by the equal sign emblazoned on a pink ("girls" color) American flag that connects Amos to the photograph. Paintings like this one represent shift and flux, abrupt transitions from one place or time to another, a collapsing of history.

Besides addressing issues of gender and class and autobiography that are the focus of Amos's earlier paintings, she exposes the art game. Several paintings and prints such as *Mrs. Gauguin's Shirt* (fig. 2.2) are subversive because they comment about the close relationship between colonialism and modernity and "post"-colonialism and postmodernity. And by their silence, artists, museums, and the academy are culpable.

Reviewing the history of German expressionism, contemporary German painting, nineteenth-century Orientalism, Amos discovered and documented an unacknowledged truth, that it is the white male artist's prerogative to depict black or "colored" people, and that he most often depicts males, usually nude. Her recent works critique white male artists' presumed authority (and unaccountability) to depict, connoting subjection, people from Third World cultures. They become symbols for cultural hegemony and gender and racial privilege. According to the dominant discourse about the politics of representation, white patriarchal society exploits black sexuality. bell hooks aptly noted that Amos "articulates the link between that whiteness which seeks to eliminate and erase all memory of darkness and that whiteness which claims the black body in representations only to hold it captive."[11] Such captivity was both an essential element of modernism and an allegory for modernity.

The authoritative male gaze is clearly evident in *Which Way Is Up George Baseless?* (artist, George Baselitz) or *A. R. Pink Discovers Black* (1993), *Malcolm X, Morley, Matisse and Me,* and *Work Suit* (1994) (artist, Lucien Freud). "It's like there's a covenant of silence about the prerogatives that [white] artists have, I wanted to let people see the freedom [these artists] have. Wouldn't it be nice if we all had that freedom?" Amos, in the center of her paintings, seizes that position literally and figuratively from white male artists in *Worksuit* (plate 7). She assumes the guise of the penultimate icon of power, the virile white male, strongly reminiscent of Tom

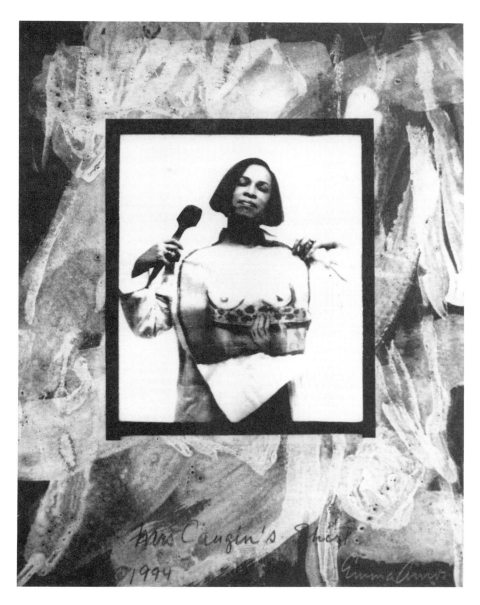

Figure 2.2.

Emma Amos.
Mrs. Gauguin's Shirt.
1994.
Silk collograph and laser
transfer photograph.
Edition of 5, no. 1.
18½ × 20¹⁄₁₆ in.
Collection of the artist.
Photograph by Becket
Logan.

Wolfe's postmodern tragedian, Master of the Universe (*The Bonfire of the Vanities*). When she dons the "worksuit," the nude body self-portrait of artist Lucien Freud, Amos inverts the iconic imagery familiar to any student of art history. Amos avoids the trap of reverse spectatorship (for example, her painting a male nude); however, she inserts irony by painting a white female nude as the object of her white male gaze, canceling implications of colonialism. Simultaneously she creates a parody of that canonical image by retaining her identity with her portrait. As such, she constructs herself as female spectator, and foregrounds what John Roberts describes as "the way painting historically has come to displace women as the authors of their own representations."[12] Amos affirms her authorship of the text and, consequently, her empowerment. Psychological and intellectual disjunctiveness emerges when blackness and womanness encounters whiteness and maleness.

Recently, the issue of cultural pluralism emerged in her work. Black figures that predominated in the earlier works are now joined by Asian and white figures. "This work reflects cultural hybridity, the reality of miscegenation, the range of skin colors among black folks, and the ubiquitous images of whiteness that are part of American experience."[13] Her telling the story of difference within difference, of miscegenation and class within the African American community is her response to the mythical essentialized black community. Amos writes:

Evoking a politics of difference, this new work is marked by a sense of inclusion and border crossing. In the mid-eighties I noticed that curators from public institutions most often chose to exhibit those of my paintings that showed only black figures, a practice that made me more attentive to my use of a multicolored mix. Every African American artist, including those whose work is more abstract or those who do not

paint recognizably "black" figures, confronts narrow curatorial definitions of "black art" that seek to influence and direct our choice of subject matter.

These acts of covert censorship should lead all artists to question critically who paints what, why, and how. Researching the impact of race, I found that white male artists are free to incorporate any image. While they may have worried about their inclusion of "colored" imagery for one reason or another, they found that work which included non-white figures was often seen as more exciting, more provocative, more sexually charged, and more noteworthy.[14]

Amos gives herself license to remark on that appropriation and the right, as a black artist, to depict white images, even to the point of masquerading as the paramount symbol of modern Western art, a white male, in *Worksuit*. It is one of the more transformational and transgressive images in African American art. And she does not care if these paintings will be indecipherable one hundred years from now. "I like the idea my art will get dated. I don't believe work is timeless, except it will be beautiful, but the nuance of meaning will be lost [unless you know the history]." Ultimately Emma Amos transforms the world of image making for blacks.[15]

A trip to Nigeria, West Africa, in 1984 irrevocably changed Carol Ann Carter's views about her art and herself. "Not so ironically, Nigeria served to clarify my perceptions of this country, throwing into high relief the mixed realities of America's cultural constructions of identity: race, class, gender, and ethnicity. The 'distance' between the two countries was much shorter than I had expected."[16] Upon seeing Hausa and Yoruba architecture and embroidered textiles, Carter revisited and explored her familiar formalist language of abstraction, seen in her earlier minimalist paintings and prints (intaglio, lithography). By interrogating her expatriate culture,

gender identity, and political spaces, along with her own identity as an African American, she became less interested in the formalist language that had marked her painting and began to work with textiles. This new visual text became a map of her ethos.

By the early 1990s, Carter's art consisted of suspended fiber (raw silk, felt, canvas) constructions. Dyed strips, sewn into rectangular shapes of cloth (new and recycled) are infused with acrylic paint; upon which stitchery, beads, metallic threads, horsehair, paint, sequins, fur, wire, sticks, manufactured "found" objects, and other miscellaneous materials are appliqued, often resulting in dense accumulations of textures and shiny and mat surfaces. In her most recent endeavor, *Living Room,* Carter's fiber constructions become total room environments.

Located in three areas, their divisions are marked by three large segments of linen, each with layers of acrylic paint of differing viscosity. The underpainting bleeds through the transparent, muted, monochromatic pigments. Amos further manipulates the linen by wire-brushing, which abrades the surface, and cuts it back to the unprimed linen. She then rubs and buffs it. The surfaces evoke weathered stucco walls that recall Carter's earlier minimalist color-field paintings and tonal prints. The unstretched linen is then sparsely embellished with found objects: a heavily stitched pouch, the stenciled word "portrait," and painted abstract motifs. Within the space lies a patched, worn, "Oriental" carpet, jackets (made by Carter) draped over individual chairs, each individually titled as in *Living Room: Garment Apron on Her Chair* (plate 8) and *Living Room: Garment on Her Chair* (fig. 2.3). The entire ensemble envelopes the viewer, who intrudes into a personal space, Carter's space.

Through the construction-paintings she critiques museums, those institutions of modernism, and the modernist canon of "high" art. *Living Room* restores the rhetorical in art. By creating a room installation, her first such endeavor, Carter effectively neutralizes the subliminal modernist presence of the art museum. During a

Figure 2.3.

Carol Ann Carter.
Living Room: Garment on Her Chair (detail).
1994.
Acrylic on linen, mixed-media, rug.
Collection of the artist.
Photograph by Victoria Veenstra.

previous exhibition, where individual fiber constructions mounted on a wall or suspended from the ceiling virtually disappeared, the gallery, she recalls, "devoured my work; its significance diminished." By intervening and minimizing the visual dominance and artificiality of the museum's architectural spaces, *Living Room* creates and privileges its own cultural references and visual spaces. The bricolage of Carter's art further subverts modernism. *Living Room* is Carter's counterpoint to institutional practice and the canonical formations of art.

The installation disregards modernism's rule that fine art and craft must be considered as dichotomies. Furthermore, Carter dismantles the notion that each gender should be associated with certain types of art production. Through synthesis and reconfiguration, distinctions between the "male identified materials of oil paint and canvas" merge with the female identified materials of stitchery, dyed cloth, and weaving. *Living Room* is a critique of male hegemonic control of art production and an acknowledgment of the domestic realm of art making and the world of women. Elements from cast-off quilts and clothing are repatched and combined with other media to create textural assemblages, but not solely as a valorization of women's domestic art. Rather, the fiber constructions comment on the virtual absence of crafts from art history, their relegated status as "crafts," not ART.

Living Room is also about autobiography and focuses on multiple identities. Metaphor and symbol are encoded in the formalism of Western abstraction (expressionist and minimalist painting) and in non-Western abstraction (bricolage, dyed cloth). Carter readily acknowledges that to be African American is to be also European, and in her case, Native American.

Loosely cut jackets have closed pouches filled with "stuff" and are decorated with appliqued buttons, beads, and sequins, dangling twists of threads and yarns, and embroidery. The patchwork surfaces seem like vestigial memorials of childhood

and family; they symbolize both the African and American roots of African American culture (West African and Caribbean sacred tunics of hunters and blacksmiths, priests and priestesses, and Shamans). The meticulous and repetitious working of fabric and stitching denotes a self-centering, when the creative process becomes ritual.[17] Carter captures the extraordinary in the mundane.

One significant symbol of African and Native American cultures and class is the pouch/apron. "The apron/pouch carries tools; it also 'backs babies,' an Afrocentric term. The apron/pouch 'carries' or may conceal, secrets. It binds, or alternatively, protects, comforts, and shelters the body. Aprons/pouches are humble workhorses which are definers of work, then cast off when work is completed."[18]

Heavy stitch work on jackets and the wall pouch (figs. 2.3 and 2.4) recall women's handiwork—mending, quilting. These allusions are not, however, about gentility and preciousness, but about an aesthetic of necessity that Carter terms "the privilege of poverty."[19] Different cultural values emerge from the puckered surfaces and thick threads. They hint at pain and healing and suggest keloids of cut and wounded black skin seen on body decorations in Africa or the whipped backs of slaves.

Layered garments are emblems of our industrial/postindustrial society, the cloaks of the shadowy nomads of our urban streets, especially women who move silently, averting their gazes, wearing layers of cloth and recycled plastic, pushing a panoply of "stuff" in shopping carts or carrying it on their bodies. The detritus of life is visible in the wrapping and layering of cloth. The garment is key to understanding *Living Room* as a transient and empowered space. It is resistant to oblivion, a symbol of survival amidst disempowerment, of protection and safety.

Carter considers her constructions as fragments of personal history and cultural reclamation. Each element has a history. One critic felt their mundane quality was disruptive of the viewer's concentration, but that ordinariness is as much a part of

Figure 2.4.

Carol Ann Carter.
*Living Room:
Reconsidered Rug and
Sand-Colored Wall*
(detail). 1994.
Acrylic on linen, mixed-
media, rug.
Collection of the artist.

history as the extraordinary. History as fabrication is exactly what this work meta-phorically represents. "They are generated by notions of accumulation, reclamation, and regeneration of lost or forgotten cultural information, they are rich in associa-tion as well as in their unorthodox use of materials."[20]

Art is not a discrete text. Stitches, pouches, stenciled words are repeated, creat-ing intertextuality. Emerging underneath or on the periphery of the wall panels are signs and clues about differing realities. Other than the physicality of the room con-struction, there is the allusion or simularcrum of a conceptual reality constructed at the junction of word, objects and environment, and where meaning is varied and not fixed. While the constructions are real in their physicality, the reality of their meaning is fragmented and convergent.

Martha Jackson-Jarvis's art also is autobiographical and focuses on cultural plu-ralism and gender. Her environments emphasize spirituality. Far Eastern medita-tiveness intersects with African and Native American ritual in these rooms of clay and mixed-media. Freestanding and wall relief sculptures of ceramics (handmade and commercially produced), and tile fragments are assembled in abstract designs and quasi-representational forms.

Her most recent installation, *Last Rites,* consists of seven coffin-shaped tables of wood called "sarcophagi," each supported by three ornamental iron legs, and wall and floor reliefs formed of scattered ceramic fragments.[21] The sarcophagi have individual titles that together embody the essential elements of our world: I: Plants, II: Earth, III: Air, IV: Water, V: Healing, VI: Blood (AIDS). The last, VII: Ancestor Spirits, approximately eight feet high, is the largest and the symbolic matrix for the smaller six sculptures.

Venetian and commercially made glass, ceramic, stone, copper, pigmented ce-ment, wood, slate, create complex textures, colors, and myriad designs. The surfaces

display a jewel-like extravagance with their incrustations. Organic forms emerge among geometric ones. The sarcophagi may represent precious medieval reliquaries or the detritus of a volcanic eruption. Deliberation balances improvisation, restraint counteracts movement.

Each sarcophagus has a unique composition of animate and inanimate forms that appear against a background of glass and ceramic tesserae. *Sarcophagus II: Earth* (fig. 2.5) has reptilian forms, snakes, and fossilized plants, shale and rock formations. *Sarcophagus IV: Water* (plate 9) is replete with fish, mostly carp, and fossilized marine invertebrates. The tesserae evoke the image of a sea bed where lie the sunken mosaic floors of antique Roman villas, or a Caribbean ocean floor with its encrusted corals and mottled blue colors, a bed of ores, minerals, and shells. Some of these sculptures appear to be tables set for a feast, offering jewels of the sea and earth, belying their titles as lifeless memorials. Their shape and height suggest an altar; a funeral pyre. The underlying theme is ritual and sacrifice.

Time and death are the significant themes. The spiral and undulating patterns of the clay fragments energize the space and symbolize time; connoting historical progression that counters modernist concepts of history as linear.

Death, a transition from one reality to another, is about destruction and rejuvenation, birth and rebirth. *Ancestor Spirit,* always preceding the six smaller sculptures, is the spiritual and physical nexus of the ensemble. The others present a panoply of iconic forms that suggest transformation and the recycling of life and nature. Their layers of materials that seem to have accumulated over time reinforce the theme of transformation. "I view *Last Rites* as talismanic forms of seven sarcophagi, embodying the sacred elements of Plants, Earth, Air, Healing, Water, Blood, and Ancestors."[22]

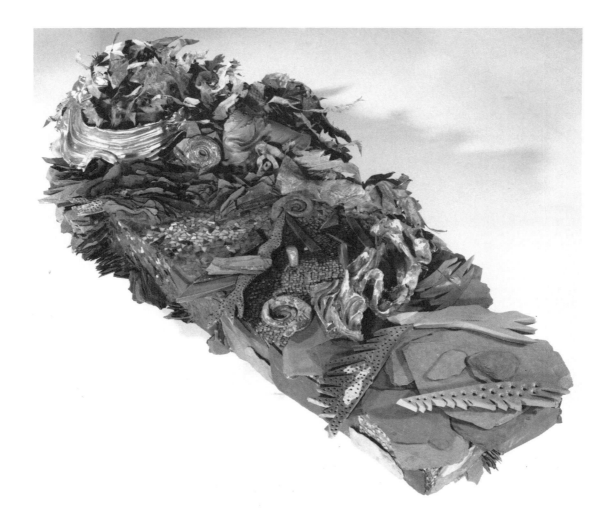

Figure 2.5.

Martha Jackson-Jarvis. *Last Rights* *"Sarcophagus II: Earth."* 1992–1993.

Clay, copper, glass, cement. 21 × 84 × 42 in. Collection of the artist.

Photograph by Harlee Little.

For example, according to the artist, *Earth* is about the "powers of earth forces that affect the directional winds and energy surrounding earth." *Sarcophagus III: Air* (fig. 2.6), representing flight, is a companion to *Sarcophagus II: Earth,* for they form "an analogy between forces of the air (birds) and forces of the earth (reptiles), representing the binding forces of the heavens and earth." *Sarcophagus IV: Water* is about the cleansing and healing forces of water symbolized by the fish, but "death heaps the life-giving carp into wasteful piles. Fossilized fish further [convey] the notion of death. Water, known for its healing powers, is polluted." Jackson-Jarvis asks: "Who will heal the healer?" The ominous question leads us to the reality of our lives. *Sarcophagus VI: Blood* is concerned with the virus AIDS and depicts a sacred object of the Yoruba/Fon African deity of sickness, Soponno, (in Africa, illness indicates an imbalance between humankind, the environment, and the spiritual). Woven within the themes of time and death are those of redemption and salvation, healing and purification: a means of reestablishing a harmonious universe. The spiritual intersects the earthly realm.

Each sarcophagus is a text about humankind's survival or demise. Jackson-Jarvis writes:

In the face of world issues about racism, sexism, ecological destruction, homelessness, economic and spiritual deprivation, war and possible planetary annihilation, contemporary artistic discourse has landed squarely on the spiritual in art. Using many cultures as resources from which to cull images and symbols, artists seek to evoke ancient knowledge and visions of man's primal strengths and fears. It is imperative to empower symbols and rituals through belief. Devoid of this potent human element of belief, symbols and ritual remain forever impotent lines and marks spent in useless

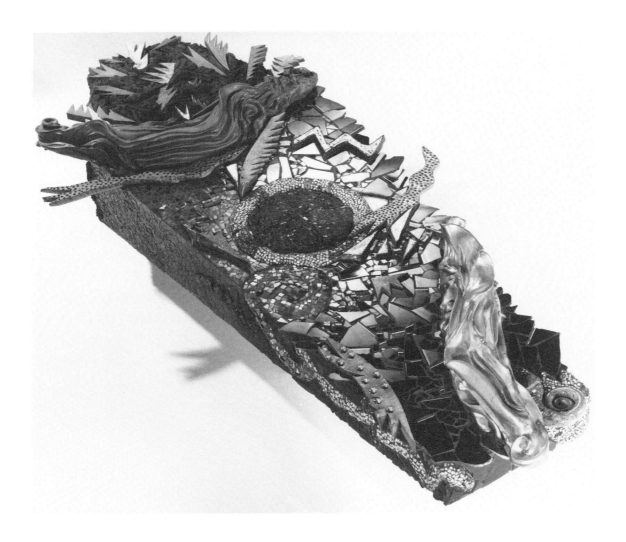

Figure 2.6.

Martha Jackson-Jarvis.
Last Rights
"Sarcophagus III: Air."
Collection of the artist.

and powerless decorative frill and performance linked only to flamboyant and arrogant gestures.

The realities of our present history call to the believers in the Maternal Goddess Spirit, for those who know the way of the Orisha, to struggle for change. For those who believe in the well-being of the planet and the peoples and animals that move about it, now is the time to invent the healing medicines of our time.[23]

Drawing upon cultures, often ancient, in and outside of the United States, Jackson-Jarvis assumes a pluralist stance in making historical and cultural icons. Scattered ceramic fragments, reminiscent of pottery shards, allude to ancient civilizations. *Last Rites* is a metaphor for the fragmented world where connective multimedia forms denote the constitutive elements of life and survival. The abundant layers of each sculpture evoke elements of culture and history, such as the mosaic Gates of Ishtar, the glass and stone mosaics of San Vitale, in Ravenna, Italy, Japanese, Korean, and Native American ceramics, Antonio Gaudí's Casa Milá or Simon Rodia's Watts Towers. As she asserts, "I am heir to everyone's knowledge."

Clay is significant for Jackson-Jarvis. "Clay is a metaphor for life, cyclical, alchemistic; I find in it a rhythm; it is enchanting, enticing, an extraordinary mechanism for movement; ultimately with cement and copper it is an extension of nature." Clay as a part of the earth refers to American Indian and African American cultures and genealogy. "There always seems to be a presence of the Native American. Maybe because we're on their soil. Their ancestors walked here, and their spirits are right here, too. You can't separate that from the rocks and the trees and the materials [akin to African philosophy]. The Native American spirit surfaces in terms of materials, forms. The basis of it all is clay."[24]

Clay creates a mnemonic text in which Jackson-Jarvis retrieves memories about culture, matriarchy, and herself. Observing her grandmother searching for the white clay used in certain family rituals, her taking broken plates and bits of pottery to the grave sites of relatives, remains indelibly a part of Jackson-Jarvis's own cultural history. Ceramic pieces represent broken crockery, a symbol of an African American folk tradition, the ritual of breaking pots as part of burial practices. This art is about black women and their role in sustaining black cultural values.[25] Each sarcophagus manifests a facet of black people's history and cultures. And Jackson-Jarvis's empowerment lies in knowing this legacy.

Improvisation within a spiritual context, the I Ching, or the Oracle of Ifa (deity of divination among the Yoruba peoples of Nigeria), merges with the pragmatic spirituality of black folk culture. As part of cultural retrieval, the process of making art is ritual. Jackson-Jarvis and Carol Ann Carter consider their actions as a way of connecting the past to the present. Each artist strives for an understanding of the sacred as an integral life experience and a holistic approach to making art. As Martha Jackson-Jarvis states:

> A key point was when I realized that my voice was important, or is important. And that I have a right to say it and do it, and I'm going to. And its limitless. I tied myself into that great tradition of folk: my grandmother, my great-grandmother, my great-grandfather. So, I feel their presence. They propel me in many ways, they protected me. The ancestral spirits are real.

The art of Emma Amos, Carol Ann Carter, and Martha Jackson-Jarvis is dialogic. Art is about the explication of ideas, issues, and critiques about modernism and the

postmodern condition, as these three artists speak to and about the differences within themselves and among each other. It is essential to understand art as a construct of culture and its role as symbol (in the production of meaning and ideology) and as commodity (in the production of wealth), and ultimately as a power sign.

Power exists when the viewer actively participates in a discourse with the artist (through her works) and the viewer acknowledges the artist (ideally her positionality) and her art. Through art they hope "to transform the spectator from a passive consumer into an active producer of meaning by engaging the spectator in a process of discovery rather than offering a rigidly formulated truth."[26] Pedagogy may be incomplete. Amos's paintings require that the viewer be familiar with the art historical canon and contemporary art so that she can successfully destabilize and reverse the roles of the signifier and the signified. Yet she also risks reifying what she deconstructs. The nonfigurative and nonspecific images of Carter's and Jackson-Jarvis's art create a more obtuse textuality. The aesthetic and symbolic character of the work of these artists draws the viewer into a dialogue.

As authors, Amos, Carter, and Jackson-Jarvis narrate their various identities. All three risk speaking *for* a black cultural group. Their challenge is to focus on, yet contest, difference with its sociopolitical and economic associations, while assuming as dialectical a position as possible in relation to identity. "Herself," however, is not fixed, unitary, essentialized. Therefore, neither is the text nor the aesthetic of their art. Subjectivity denotes a particular moment, place, a set of experiences. "The 'self' in the discourse of postmodernity is only an unstable amalgam of identities existing in a fabric of social relations that is now more complex and mobile than ever before."[27] Among the three artists, Amos most overtly represents her socially constructed self. Her phobic, allegorical self-portraits are seen in the context of cultural colonialism, social, economic, and political corruption. Amos directs her anger and

anxieties to the viewer about exploitation and oppression against people in Africa, Tahiti, Oceania, and the Caribbean. As signifier, she inverts the politics of her own, and by extension, other women of color's gender and racial oppression as signified subject.

Carol Ann Carter's and Martha Jackson-Jarvis's self-portraits are not mirror reflections but are conveyed through materials and forms. Their cultural and political agenda is more subtle and concealed, consequently their work is at greater risk of misinterpretation. Their art's virtual absence from the postmodernist discourse attests to its unfamiliar production of meaning. For Carter, pouches, clothing, and painted walls are her environments of personal memory. "My works are a reflection of discovery and reclamation [which] happens for me through the use of materials, literally in the handling of them." Family and neighborhood as *culture* allowed her to value them alongside academic training as a major shaper of her variegated aesthetic preferences. For Jackson-Jarvis, clay and terra-cotta fragments are the materials of personal memory. By its mere presence, clay represents her childhood, maternal grandmother, and family rituals. Clay also conveys her deep spiritual beliefs, for the earth is the world of the ancestors. Jackson-Jarvis and Carter encase and enfold respectively, memories, making each installation a memorial about self.

The art of Amos, Carter, and Jackson-Jarvis dismantles the canonical categories of "high/low" art, and what is viewed as women's art. Textiles and pottery, often thought of as a "women's" hobby, as domestic art, or as handicraft, are often characterized as personal, implying a lack of quality or of some aesthetic universality, and therefore apolitical and insignificant. But the personal is political, if we view this type of art as manifesting the politics of women's oppression rather than as a uniquely feminine social condition.[28] So too, much African American art is relegated to craft-art, or folk art, even though such distinctions and gender-associated art

forms were irrelevant in early (and some would argue even today) African American art history.

By mixing materials regardless of their commodity value, retrieving the artistic legacy of Africa where art and craft are the same endeavor, and by incorporating motifs from black folk art, they create a new kind of art. By doing so they circumvent those who would misconstrue their efforts as only feminist, feminine, and apolitical. In claiming the African American heritage and reclaiming the African one, each avoids delimiting categories of crafts/folk by employing modernist, that is, masculine, European modes of art production privileged by art museums and critics—painting (including mosaic art) and sculpture. As postmodernists they endeavor to "break the rules" by using modernism's aesthetics combined with folk or "low" art materials in order to expose and critique modernist assumptions of the inherent importance given to certain art media and forms. Furthermore, there is the issue of class, with its intersection with race and gender where necessity is the handmaiden of creativity. As mentioned earlier, Carol Ann Carter described her own work, as "'privilege of poverty' or opportunities that can arise from not always having had access to the 'best' of everything that this culture values and promotes."

The connection between art and ritual, art and culture is the aesthetic of improvisation. Traditionally within the African American community, as part of the folk culture, although not necessarily a black prerogative, improvisation is a survival technique as well as an aesthetic derived from African culture. Improvisation as such is a key signifier of blackness, a process admitted by Carter and Jackson-Jarvis who intentionally use it as a signature of their work.

These artists also employ what Western modernists consider an anti-aesthetic: bricolage, an effective postmodernist tool to create inventive art. Bricolage, recognized by the surrealists as an effective method representing African art, functioned

then as today as cultural counterpractice. Bricolage ruptures modernist aesthetics and Western cultural identity as represented through art. As such, bricolage is transgressive.[29] Amos, Carter, and Jackson-Jarvis employ, in varying degrees, bricolage to invert the appropriation of "primitive" art by Western modernist artists (which coincidentally occurred during the expansion of European colonialism). This is achieved by reclaiming the aesthetic of African art: the use of assemblage, "found" materials, improvisation, accumulation of materials, formal contradictions and tensions. Furthermore, they realize bricolage functions as a metaphor for the black experience and gives more meaning to their work.

Amos, Carter, and Jackson-Jarvis belong to what Trinh T. Minh-ha identifies as the "Third World in the First World," those who have been brought up in white culture, yet who feel connections to Third World, African, and Native American cultures. Their critical voices have heretofore been ignored because they did not conform to preconceptions about black women and black artists. Their art, representative of African, Native American, and Euro-American cultures, fosters contradiction, allows for differences and cultural complexities about blackness. All three artists use monolithic propositions such as multiculturalism and feminism (and postfeminism),[30] but deconstruct them at the same time, by claiming their sexuality, race, ethnicity, and individuality. Risking alienation, they want the viewer to encounter difference on its own terms. They are, as Adrian Piper noted, those who are critically distanced from the status quo both politically and aesthetically; who see the mainstream clearly because they've been excluded from it while having to navigate through it; and who are unwilling to accept the narrow range of aesthetic options validated by the mainstream.[31]

The artists' use of improvisation and bricolage and their concern with spirituality reveal the social condition of blackness and shed light on the meaning of African

American women's postmodernist art. At the same time, they use art processes and strategies of Western art. Consequently, their works convey what it means to be black *and* female in the United States. The art of Emma Amos, Carol Ann Carter, and Martha Jackson-Jarvis gives us a glimpse of living "fearlessly with and within difference(s)."[32]

Notes

1. This chapter, whose title is derived from Trinh T. Minh-ha's writings (see note 32), developed from a paper entitled "The Agenda Now: Socially Conscious Art and the Feminist Perspective" presented at a symposium of postmodernism and African American art, held at the Hirshhorn Museum and Sculpture Garden, Smithsonian Institution, March 30, 1991. In this revision, I selected three women artists to establish some parameters to the essay and to illustrate/expand upon our knowledge of postmodernist art from a black perspective. The selection of these three artists should not be construed as privileging them over other black artists. All artists quotes not referenced in text are based on personal communication.

2. Hal Foster, "Re: Post," in Brian Willis, ed., *Art after Modernism: Rethinking Representation* (Boston: David R. Godine, Publishers, 1984), 189.

3. Steven Connor, *Postmodernist Culture: An Introduction to Theories of the Contemporary* (New York: Basil Blackwell, 1989), 81. The following paragraph is based on readings of the following. Connor, *Postmodernist Culture*, 82–83. Francis Francina and Jonathan Harris, eds., *Art in Modern Culture: An Anthology of Cultural Texts* (New York: Harper Collins, 1992).

4. Connor, *Postmodernist Culture*, 224–25. Colin Gorgon, ed., *Michel Foucault: Power/Knowledge, Selected Interviews and Other Writings, 1972–1977* (Brighton, England: The Harvester Press, 1980). Edward W. Said, "Michel Foucault, 1926–1984," in Jonathan Arac, ed., *After Foucault* (New Brunswick: Rutgers University Press, 1988), 1–11. For a discussion and summary of Michel Foucault's notion of power in the formation of feminist discourse, see Shelagh Young, "Feminism and the Politics of Power," in *The Female Gaze,* ed. Lorraine Gamman and Margaret Marshment (London: Womens Press, 1988), 180–83.

5. John Roberts, *Postmodernism, Politics and Art* (Manchester, England: Manchester University Press, 1990), 4. For remarks about modernism, postmodernism, and feminist art

history, see Griselda Pollock, "Feminist Interventions in the Histories of Art: An Introduction," in *Vision and Difference: Femininity, Feminism, and Histories of Art* (New York: Routledge, 1988), 1–17.

6. Connor, *Postmodernist Culture,* 88–96.

7. Adrian Piper states that women artists of color have serious concerns about three of the tenets of postmodernism, namely that their work has "no halcyon past to mourn," the belief that there is no objective truth, and the claim about the impossibility of innovation. Adrian Piper, "The Triple Negation of Colored Women Artists," in *Next Generation: Southern Black Aesthetic,* ed. Lowery Sims (Winston-Salem, N.C.: Southeastern Center for Contemporary Art, 1990).

8. Shelagh Young refers to the writings of Michel Foucault, "Afterword: The Subject of Power," in *Michel Foucault: Beyond Structuralism and Hermeneutics* (1982), in "Feminism and the Politics of Power," in *The Female Gaze,* ed. Lorraine Gamman and Margaret Marshment (London, The Women's Press, 1988), 183.

9. Kobena Mercer, "Black Art and the Burden of Representation," *Third Text* 4 (spring 1990): 61–78. Mercer sees two meanings to the term "representation," one is the "practice of depiction and textual production"; the other is the "practice of delegation and substitution." The latter Mercer understands as the black artist *speaking for* the black communities. Griselda Pollock defines representation as, one, the "convention and codes of practices of representation, painting,

photography"; two, "visualizations of social practices and forces which we theoretically know condition our existence"; and three, a method of signifying "something represented to, addressed to a reader/viewer/consumer." The third definition is a modification ("a speaking to") of Mercer's "a speaking for." Pollock, *Vision and Difference,* 6.

10. Manthia Diawara used the term "kitsch," as it is defined by Clement Greenberg, as the opposite of fine art, i.e., "art and kitsch," in his discussion about black popular culture. Manthia Diawara, "Afro-Kitsch," in *Black Popular Culture,* ed. Gina Dent (Seattle: Bay Press, 1992), 283–91.

11. bell hooks, "Aesthetic Intervention," in *Changing the Subject* (New York: Art In General, 1994), 6. Amos, currently a professor of art at Mason Gross School of the Arts, Rutgers University, studied at London Central School of Art, England, and New York University (M.A.). She has had several solo exhibitions, most recently a retrospective, *Emma Amos: Paintings and Prints, 1982–1992* in 1993 and *Changing the Subject: Paintings and Prints, 1992–1994* at Art In General, New York City, in March 1994. In 1993, she received a residency fellowship for Bellagio, Italy, from the Rockefeller Foundation.

12. Roberts, *Postmodernism,* 4.

13. Emma Amos, "Artist's Statement," in *Changing the Subject* (New York: Art In General, 1994), 3.

14. Amos had her works depicting whites rejected for exhibitions, presumably because to white curators, black art means depiction of

black figures. Judith Wilson addresses the same concerns as a form of neocolonialism, see "Seventies into Eighties—Neo-Hoodism vs. Postmodernism," in *The Decade Show* (New York: New Museum of Contemporary Art, 1990), 130n3. In the 1960s and 1970s, the same issues were debated and discussed by artists and critics: self-imposed censorship by black artists to accommodate both curatorial practice and the art market and the attempt to define a black aesthetic. During that time, artists were rejected by mainstream curators and critics because they depicted black images.

15. Thalia Gouma-Peterson, "Reclaiming Presence: The Art and Politics of Color in Emma Amos's Work," in *Emma Amos: Paintings and Prints, 1982–1992* (Wooster, Ohio: The College of Wooster Art Museum, 1993), 5–14. bell hooks, *Yearning: Race, Gender and Cultural Politics* (Boston: South End Press, 1990).

16. Unpublished typescript, 12 May 1994, collection of the artist. Detroit Institute of Arts, *Thom Bohnert, Carol Ann Carter* (Detroit: Detroit Institute of Arts, 1989), 10. Carol Ann Carter, currently associate professor, School of Art and Architecture, University of Michigan, studied at the Herron School of Art, Indiana University (B.F.A.) and the University of Notre Dame (M.F.A.). She has had several solo exhibitions, including *Celebrating Difference* at the University of Rhode Island in 1993 and *Carol Ann Carter: Living Room* at the Indianapolis Museum of Art in 1994. She

received a National Endowment for the Arts fellowship in 1984.

17. Lucy Lippard sees in women's patching and repairing of cloth, "transformational rehabilitation." Carter considers her work a metaphor for healing. Lucy Lippard, *Get the Message?* (New York: E. P. Dutton, 1984), 103.

18. Fine Arts Center Galleries, University of Rhode Island, *Carol Ann Carter: Celebrating Difference* (Kingston: Fine Arts Center Galleries, University of Rhode Island, 1993), 4.

19. Unpublished typescript, 12 May 1994, collection of the artist.

20. Detroit Institute of Arts, *Thom Bohnert, Carol Ann Carter,* 10. Lonnette M. Stonitsch, "Isobel Neal Gallery, Chicago, Carol Ann Carter," *New Art Examiner* 17 (January 1990): 41.

21. Martha Jackson-Jarvis, currently teaching at Maryland Institute, College of Art, studied at Temple University (B.F.A.) and Antioch University (M.F.A.). She has participated in numerous group exhibitions, most recently, *Artists Respond: New World Question* at the Studio Museum in Harlem in 1993 and *Sources: Multicultural Influences on Contemporary African American Sculptors* at the University of Maryland in 1994. She received an Arts International Lila Wallace-Readers Digest Grant in 1992.

22. The Studio Museum in Harlem, *Artists Respond: New World Question* (New

York: The Studio Museum in Harlem, 1993), 12.

23. Unpublished typescript, 12 May 1994, collection of the artist. Regarding mother-goddess archetypes, see Carol Bigwood, *Earth Muse: Feminism, Nature and Art* (Philadelphia: Temple University Press, 1993); Estella Lauter, *Women as Mythmakers: Poetry and Visual Art by Twentieth Century Women* (Bloomington: Indiana University Press, 1984), 45–46; and Gloria Feman Orenstein, "The Reemergence of the Archetype of the Great Goddess in Art by Contemporary Women," in Arlene Raven, *Feminist Art Criticism* (New York: Harper Collins, 1991), 71–86.

24. The Art Gallery, University of Maryland, *Sources: Multicultural Influences on Contemporary African American Sculptors* (College Park: The Art Gallery, University of Maryland, 1993), 5. The mind-body totality cited in the literature as feminist is more closely aligned, for Jackson-Jarvis, to African and Native American cultures whose philosophies are inclusive as "both/and" rather than Western philosophies that construct gender oriented dichotomies as "either/or." Bigwood, *Earth Muse: Feminism, Nature and Art.*

25. David C. Driskell, *Contemporary Visual Expressions* (Washington, D.C.: Smithsonian Institution Press, 1987), 29–34. For a survey of African American burial practices using broken crockery see John Vlach, *The Afro-American Tradition in Decorative Arts* (Cleveland: Cleveland Museum of Art,

1978). Crockery also alludes to the African Yoruba deity Yemoja.

26. Judith Barry and Sandy Flitterman, "Textual Strategies: The Politics of Art Making," in *Reframing Feminism: Art and the Women's Movement, 1970–1985*, ed. Rozsika Parker and Griselda Pollack (London: Pandora Press, 1987), 320.

27. S. Young cites theory of J. F. Lyotard, *The Postmodern Condition: A Report on Knowledge* (1986), 15, in "Feminism and the Politics of Power," in Gamman and Marshment, *The Female Gaze*, 187. Caren Kaplan, "Deterritorialization: The Rewriting of Home and Exile in Western Feminist Discourse," *Cultural Critique* 6 (spring 1987): 187–198.

28. Laura Mulvey and Peter Wollen, "Frida Kahlo and Tina Modotti," in *Art in Modern Culture: An Anthology of Cultural Texts*, ed. Fracina and Harris (New York: Harper Collins, 1992), 151–52. Lippard, *Get the Message?* 99–100. Barry and Flitterman, "Textual Strategies," 315–16.

29. Hal Foster, *Recodings: Art, Spectacle, Cultural Politics* (Seattle: Bay Press, 1985), 200–202. Mercer, "Black Art and the Burden of Representation," 75. Trinh T. Min-ha, *Woman, Native, Other* (Bloomington: Indiana University Press, 1989), 62–63n29. Judith Wilson discusses the relevance of "bricolage" in the works of painter Wifredo Lam and mixed-media artist, David Hammons; see Wilson, "Seventies into Eighties," 131. Lucy Lippard discusses "bricoleurs" and "crafts" in *Get the Message?* 100.

30. Whitney Chadwick, "Women Artists and the Politics of Representation," in Raven, *Feminist Art Criticism,* 167–68. For their positions regarding oscillation of margin and center in the construction of personal and political identities as feminist strategies, see Kaplan, "Deterritorialization," 188–89. Craig Owens in his remarks about postmodernist theories and the omission of the feminist "voice," excludes black artists in his discussion about the "other." Craig Owens, "The Discourse of Others: Feminists and Postmodernism," in *The Anti-Aesthetic: Essays on Postmodern Culture,* ed. Hal Foster (Seattle: Bay Press, 1983), 57–82. Anne Friedberg,

"Mutual Indifference: Feminism and Postmodernism," in *The Other Perspective in Gender and Culture: Rewriting Women and the Symbolic,* ed. Juliet MacCannel (New York: Columbia University Press, 1990), 39–58. Pollock, *Vision and Difference.*

31. Piper, "Joy of Marginality," *Art Papers* (July/August 1990) 14n4.

32. Minh-ha, *Woman, Native, Other,* 84. Also "Of Other Peoples: Beyond the 'Salvage' Paradigm," in *Discussions in Contemporary Culture,* ed. Hal Foster (Seattle: Bay Press, 1988), 138–41.

Bibliography

The Art Gallery, University of Maryland. *Sources: Multicultural Influences on Contemporary African American Sculptors.* College Park: The Art Gallery at the University of Maryland, 1994.

Art In General. *Emma Amos: Changing the Subject.* New York: Art In General, 1993.

Berger, Maurice and Johnetta Cole, eds. *Race and Representation: Art/Film/Video.* New York: Hunter College Art Gallery, 1987.

College of Wooster Art Museum. *Emma Amos: Paintings and Prints, 1982–1992.* Wooster, Ohio: The College of Wooster Art Museum, 1993.

Collins, Patricia Hill. *Black Feminist Thought.* New York: Routledge, Chapman and Hal, 1991.

Connor, Steven. *Postmodernist Culture: An Introduction to Theories of the Contemporary.* New York: Basil Blackwell, 1989.

Dent, Gina, ed. *Black Popular Culture.* Seattle: Bay Press, 1992.

Detroit Institute of Arts. *Thom Bohnert and Carol Ann Carter.* Detroit: Detroit Institute of Arts, 1989.

Driskell, David. *Contemporary Visual Expressions.* Washington, D.C.: Smithsonian Institution Press, 1987.

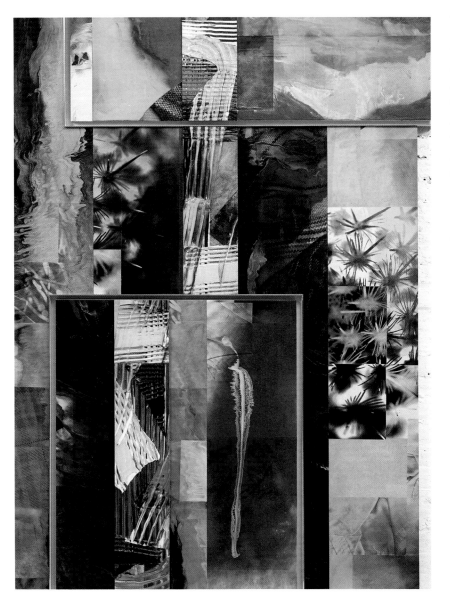

Plate 1

Sam Gilliam.
New Movie. 1994.
Acrylic on fabric and
computer-generated
images, mounted on
wood with aluminum
framed elements,
constructed.
80 × 56.5 in.
Courtesy of
Baumgartner Galleries,
Washington, D.C., and
Imago Galleries, Palm
Desert, California.
Photograph by Mark
Gulezian.

Plate 2

Joyce Scott.
Buddah Supports Shiva Awakening the Races.
1993. Sculpture with beads and mixed media.
14 × 15 × 6 in.
Photograph by Kanji Takeno.

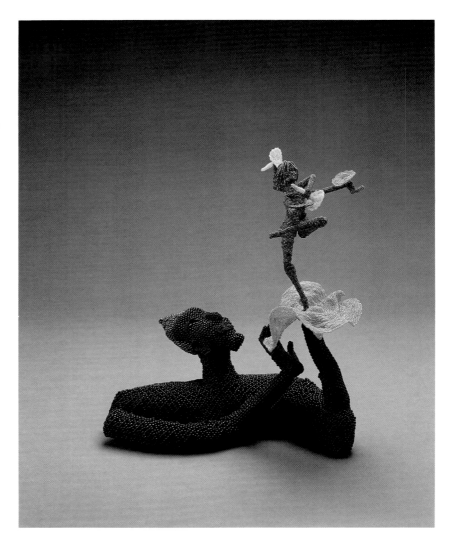

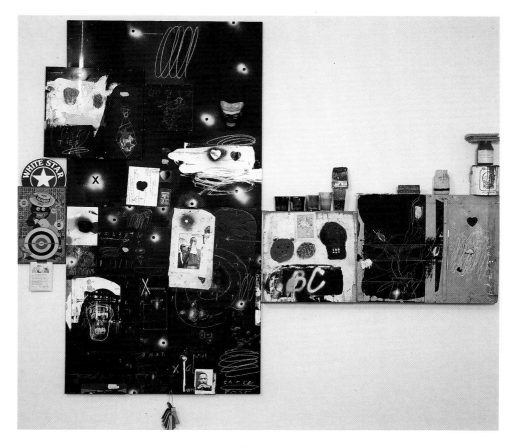

Plate 3

Raymond Saunders.
Black Men, Black Male:
Made in the U.S.A.
1994.

Mixed media.
105 × 119 × 7¼ in.
Stephen Wirtz Gallery,
San Francisco.

Plate 4

The Wall of Respect.
1967.
43rd and Langly Streets,
Chicago.
20 × 60 ft.
Photograph by Mark
Rogovin and Tim
Drescher.

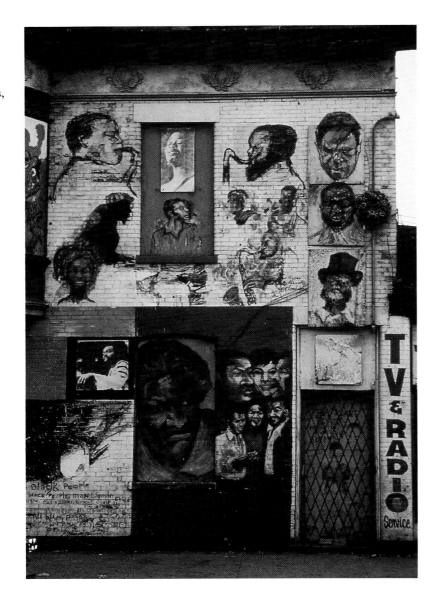

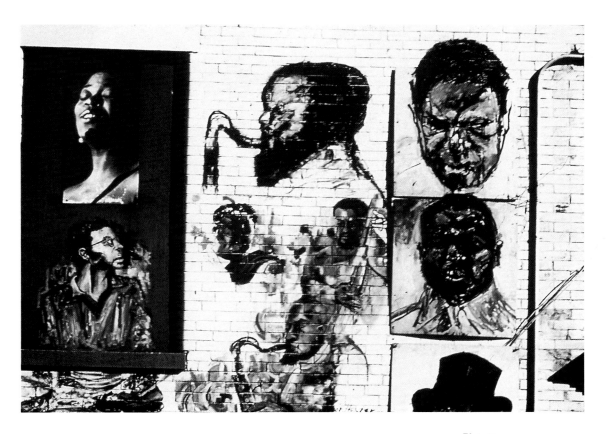

Plate 5

The Wall of Respect
(detail). Photograph by
Mark Rogovin and Tim
Drescher.

Plate 6

Edouard Duval-Carrié.
Patrouille des Esprits.
1993.
Oil on canvas with
artist's frame.
71 in. × 78¾ in.
Courtesy of the artist.

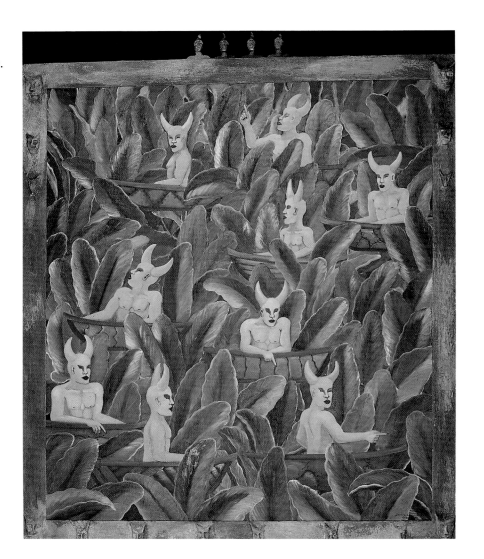

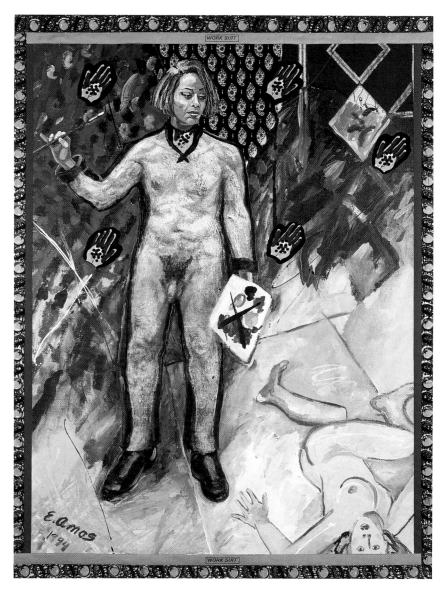

Plate 7

Emma Amos.
Worksuit. 1994.
Acrylic on linen canvas,
and African fabric.
74½ × 54½ in.
Collection of the artist.

Plate 8

Carol Ann Carter.
*Living Room: Garment
Apron on Her Chair*
(detail) (actual
installation). 1994.
Acrylic on linen, mixed-
media, rug.
Collection of the artist.

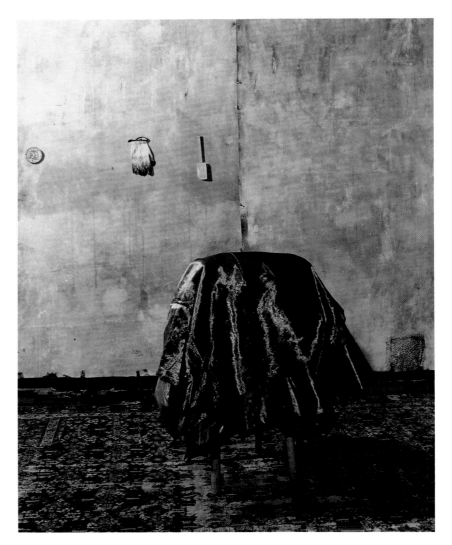

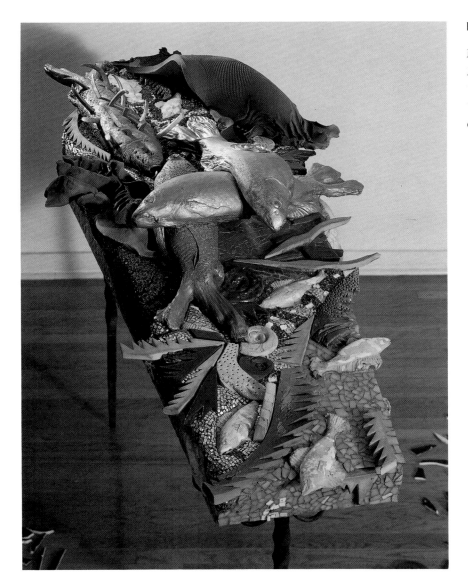

Plate 9

Martha Jackson-Jarvis.
Last Rights
"Sarcophagus IV:
Water." 1992–1993.
Collection of the artist.

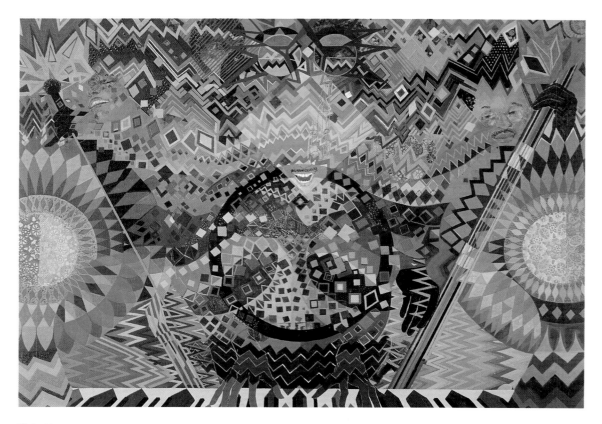

Plate 10

Jeff Donaldson.
*Jam Packed and Jelly
Tight*. 1988.
Mixed media on canvas.
36 × 50 in.
Collection of the artist.

Plate 11

Beverly Buchanan.
*Tribute to Mary Lou
Furcron.* 1989.
Wood and twigs.
12⅜ × 9¼ × 7½ in.
Private collection,
Athens, Georgia.
Courtesy Steinbaum
Krauss Gallery, New
York City.

Plate 12

Beverly Buchanan.
*Ms. Mary Lou Furcron's
House*. 1989.
Oil pastel on paper.
38½ × 50 in.
Courtesy Steinbaum
Krauss Gallery, New
York City.

Plate 13

Beverly Buchanan.
*Ms. Mary Lou Furcron's
House*. 1989.
Ektacolor print.
16 × 20 in.
Courtesy Steinbaum
Krauss Gallery, New
York City.

Plate 14

Joe Overstreet.
Strange Fruit. 1963.
Oil on canvas.
46 × 40 in.
Collection of the artist.
Photograph by Joe
White.

Plate 15

Fred Wilson.
*Picasso: Whose Rules
(with Video)*. 1991.
Photo, mask, and video.
95 × 100 × 68 in.
Metro Pictures, New
York.

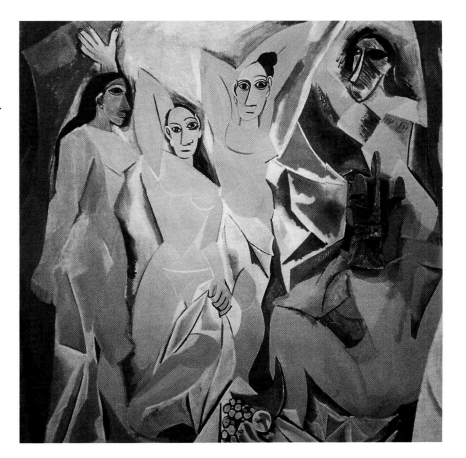

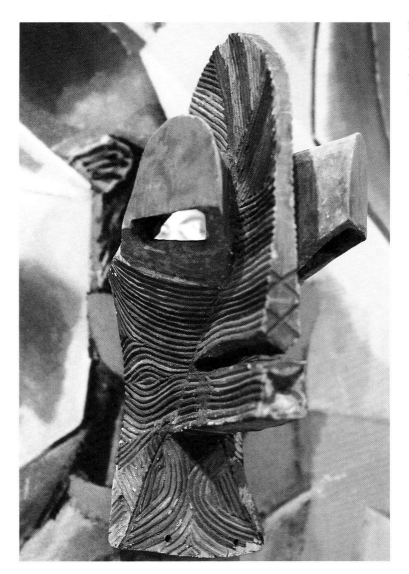

Plate 16

Fred Wilson.
Picasso: Whose Rules
(detail).

Plate 17

Norman Lewis.
Untitled. 1978.
Oil on canvas.
50 × 72 in.
The Metropolitan
Museum of Art,
Purchase, the George A.
Hearne Fund, by
exchange, and the
Eugene and Estelle
Ferkauf Foundation
Gift, 1991. (1991.47)

Ferguson, Russell, M. Gever, T. T. Minh-ha, and C. West, eds. *Out There: Marginalization and Contemporary Cultures*. Cambridge, Mass.: MIT Press, 1990.

Fine Arts Center Galleries, University of Rhode Island. *Carol Ann Carter: Celebrating Difference*. Kingston, R.I.: Fine Arts Center Galleries, University of Rhode Island, 1993.

Foster, Hal. *Recodings: Art, Spectacle, Cultural Politics*. Seattle: Bay Press, 1985.

Gilroy, Paul. *The Black Atlantic: Modernity and Double Consciousness*. Cambridge, Mass.: Harvard University Press, 1993.

hooks, bell. *Black Looks: Race and Representation*. Boston: South End Press, 1992.

———. *Yearning: Race, Gender, and Cultural Politics*. Boston: South End Press, 1990.

Indianapolis Museum of Art. *Carol Ann Carter: Living Room*. Indianapolis: Indianapolis Museum of Art, 1994.

Intar Gallery. *Autobiography: In Her Own Image*. New York: Intar Gallery, 1989.

Lippard, Lucy. "Floating, Falling, Landing: An Interview with Emma Amos," *Art Papers* 15, no. 6 (November/December 1991): 13–16.

———. *Mixed Blessings*. New York: Pantheon Books, 1990.

Mbiti, John S. *African Religions and Philosophy*. 2d ed. Portsmouth, N.H.: Heinemann Educational Books, 1989.

McEvilley, Thomas. *Art and Otherness: Crisis in Cultural Identity*. Kingston, N.Y.: McPherson, 1992.

New Museum of Contemporary Art. *The Decade Show: Frameworks for Identity in the 1980s*. New York: New Museum of Contemporary Art, Museum of Contemporary Hispanic Art, and the Studio Museum in Harlem, 1990.

Parker, Rozsika and Griselda Pollack, eds. *Reframing Feminism: Art and the Women's Movement, 1970–1985*. London: Pandora Press, 1987.

Piper, Adrian. "The Triple Negation of Colored Women Artists," 15–22, in Lowery Sims, *The Next Generation: Southern Black Aesthetic*. Winston-Salem, N.C.: Southeastern Center for Contemporary Art, 1990.

Raven, Arlene, C. Langer, and J. Frueh, eds. *Feminist Art Criticism*. New York: Harper Collins, 1991.

Studio Museum in Harlem. *Artists Respond: The New World Question*. New York: Studio Museum in Harlem, 1993.

3

The African American Aesthetic and Postmodernism

ANN GIBSON

Is there any reason to talk about postmodernism and an African American aesthetic together? Are they irreconcilably different, or are there areas of overlap? According to Robert L. Douglas (who draws on Martin Bernal's *Black Athena* as well as his knowledge of the AfriCobra aesthetic) multidominant cultural elements have distinguished the arts of Africa and African-descended peoples from ancient times to the present. This appears in the visual arts as a predisposition to apply colors in layers and in intense tones, to use multiple textures, patterns, and shapes in "jampack," "jellytight" compositions. In twentieth-century American art, one can observe the workings of this tendency in the flat patterns of Aaron Douglas, Lois Mailou Jones, Hale Woodruff, and in the work of later artists Frank E. Smith, Wil-

liam T. Williams, James Phillips, Charles Searles, Howardena Pindell, and Jeff Donaldson (plate 10).[1]

Although Robert Douglas admits that many of the artists whose work he cites as examples of an African American aesthetic would claim that their version of it (or of a broader category, one that Jeff Donaldson calls "TransAfrican" art) has cultural and social elements as well (see Chapter 5), Douglas bases his definition of an African American aesthetic on visual form rather than narrative content or political intention because it is more inclusive: "My form-based theory can be applied to most African American expressions," he wrote.[2]

Following Roland Barthes, Hal Foster usefully defined postmodernism as distinct from a modernism that saw itself as whole, "sealed by an origin (i.e., the artist) and an end (i.e., a represented reality or transcendent meaning)." The postmodern, in contrast, is "'a multidimensional space in which a variety of writings, none of them original, blend and clash.'" The difference, Foster concluded, was that modernism has been posited as a sign: "a stable unit composed of signifier [in the case of art, the physical aspect of the painting or weaving] and signified [our understanding of what it refers to]." Postmodernism, in contrast, admits "the contemporary dissolution of the sign and the released play of signifiers."[3]

Roland Barthes's example helps to make this clear. "Take a black pebble," he wrote, "I can make it signify in several ways, it is a mere signifier; but if I weigh it with a definite signified (a death sentence, for instance, in an anonymous vote), it will become a sign."[4] In modernist thinking, the pebble must continue to carry its original signification. But in postmodern thinking, meaning may be reassigned again and again, and the physical object may carry more than one of these meanings, old and new, at the same time. Thus it is impossible to say which is the "true" meaning. In fact, in postmodern thinking, it is when several meanings are read in the same word or object so that they may resonate or clash, that the actual nature of the

production of meaning is most evident. Some of the activities now considered post-modern—activities that depend for the variety of their meanings on this "play of signifiers"—are also, as Floyd Coleman has noted, part of an historically African aesthetic retained in much African American culture: the revision of the idea of the masterpiece, the analysis of media input, and a nonhierarchical treatment of popular and fine arts.[5]

Beverly Buchanan's shacks, which in some ways allegorize the lives of their inhabitants, exemplify these: Buchanan rejects "masterly" technique; she exhibits her shacks, both constructed and drawn, (plates 11 and 12) along with material in graphic media—photographs of the originals (plate 13) and written legends. Each contributes an element unavailable in another medium. Her attentive reconstructions suggest that she considers that the vernacular structures (for example, "low" art)—the shacks—to which her own ("high") art refers are similar in cultural and artistic value. She has put herself into her descriptions of the shacks, too. Of Mrs. Furcron's house, which Buchanan photographed both during and after the time Mrs. Furcron lived there, Buchanan wrote: "I miss her more than she knows. Her house looks abandoned as her yard and gardens show. Apparently one time she 'got loose' from the nursing home and walked ten miles toward her home. I can hardly make it up a small hill."[6]

But while Buchanan's work certainly represents the cultural and social aspects of the African American experience present in Donaldson's TransAfrican art, and while it may be claimed as postmodernism in Coleman's terms, it sits less easily with other elements of postmodernism. As Adrian Piper has pointed out, the work of "colored women" artists, work that focuses on identity, autobiography, selfhood, racism, ethnic tradition, gender issues, and spirituality, threatens not only Euroethnic art history's centrality, but also its claim to truth, since Euroethnic art historians have consistently excluded the work of artists of color.[7] Postmodernism's claim that there

is no objective truth, that truth cannot be established by the Enlightenment tools of reason and science, denies the power of the evidence and effect of decades of prejudice against artists of African descent, and denies as well the unambiguous terms in which the polyphonic richness of African American art addresses those who understand African American experience.[8] African American art like Melvin Van Peebles's early (1971) "postsoul" film *Sweet Sweetback's Baadasssss Song,* for example, defiantly used street culture to redefine black identity and challenge mainstream taste.[9] The grit and juice felt by some who observed Joe Overstreet's painted legs with sneakers swinging over Klansmen whose blue, red, and orange masks echo Billie Holiday's "strange fruit and black bodies, hanging from a sycamore tree" (plate 14), depends on viewers' realization that he stood the ambiguity of the abstract expressionist language on its head by making it refer to a specific text and a particular history. These and other artists in this essay exemplify some of the postmodern developments Coleman described.

Yet at the same time, most of these artists who have chosen to treat aspects of an African American experience conspicuously refuse to subscribe to postmodernism's belief that meaning is a chameleon, with no basis in lived reality.[10] Perhaps this is because the modernist "originality" that is disdained by postmodern, or poststructural critics, claims an absolute kind of priority, whereas the originality that may be observed in the work of Buchanan, Peebles, and Overstreet is more situational: it is a way of thinking, of negotiating that adapts as the price of survival some of the attitudes the mainstream takes as a given while at the same time rejecting others. These artists and many other artists of color have succeeded, despite their marginalization in a European-centered culture (America), in producing art that may be said, following Molefi Kete Asante, to be "congruent with the core culture," (that is, African culture).[11] Their position as both inside and outside the postmodern may be

explained as a determination to produce work that answers to more than one cultural ideal. This, however, suggests the fundamental level of these artists' allegiance to the performance of "multiple yet equally important tasks"—in this case semiotic play that supports, as opposed to invalidating, social relevance—a skill that theorists such as Alan P. Merriam, Robert F. Thompson, and Robert L. Douglas have all identified as basic to a number of African aesthetics.[12]

As Sharon Patton notes in Chapter 2, postmodernism has also codified "otherness," a concept that may do more to perpetuate the fact that some artists are seen as central while others are classed as marginal than it does to break this system down.[13] Nor are tensions between what Sims here calls "mainstream" and "blackstream" helped by the fact that both postmodernism and its predecessor, modernism, used the forms of African art but paid little attention to their meaning to the people who made them.[14] To get to the trouble between postmodernism and the African American aesthetic it is helpful to recall modernism's split history.

On one side of this split was Pablo Picasso's cubism and collage, which, like modernity in the avant-garde in general, as Sims notes here, "developed on the back of black creativity (be it tribal art, jazz, rock and rap, all the synchronistic art forms we have created to survive within the Western world. . . ." This phenomenon has been apparent to African Americans, although it has not been widely remarked in the art history written by European Americans. "As it was widely interpreted among a black middle-class intelligentsia in the '50's and the '60's," recalled Michele Wallace, "'they,' or white Euro-American high Modernism, had borrowed from 'us,' the African peoples of the world, even if 'they' were incapable of admitting it." But black modernism, like black postmodernism, "signifies" on this appropriation (that is, reassigns it new meanings that parody the old), using not only references unique to African American experience, but also European styles and processes, to call into

question the relationships between African American and European American culture.[15]

Fred Wilson's *Picasso: Whose Rules (with Video)* (1991) (plate 15), based on Picasso's *Les Demoiselles d'Avignon,* makes the act of signifying into part of its subject matter by mounting a contemporary Kifwebe mask made for the trade over the most abstract of Picasso's Africanizing heads. Peering through the eye-holes in the mask (plate 16) one can see Wilson himself in company with a Senegalese man and a Senegalese woman asking passersby: "If our art or religion becomes your art or history, whose rules say what is cliché? . . . Whose rules decide what is great?"

Postmodernism, like modernism, acknowledged the fragility, fragmentation, discontinuity, and chaos of contemporary life. Some examples of both modern and postmodern art have been seen as opposed to the social and political assumptions of the societies that produced them. Linda Hutcheon separated the modern (for example, the purist formalism of Eliot and Ortega y Gasset) from the avant-garde (for her, the politicized opposition of Brecht, the antagonism to both market value and the concept of genius manifested by Duchamp). Postmodernism, she claimed, descended from the oppositional avant-garde of Brecht and Duchamp and so partakes of its example of subversion and democratization of high art. But for Hutcheon, postmodernism lacks the old avant-garde's "overt and defining oppositionality."[16]

Like Hutcheon, Peter Wollen saw two streams. He differentiated between his "two avant-gardes" in ways similar to those Hutcheon used to distinguish her "modern" from her Brechtian "avant-garde." Cubist procedures fueled what appeared to be a crucial semiotic shift in Western art, Wollen noted, establishing an avant-garde that practiced the disjunction that cubism opened between signified and signifier, but in ways that eventually went in quite different directions.[17] As a result, Picasso's collage, in particular, was understood to have closed a door between art and that to

which it referred, making it possible, and indeed, necessary, for avant-garde art to appear to be indifferent to political and social issues.[18] One direction, called "modern" by Hutcheon and characterized by Wollen as the work of the historic avant-garde, became especially prevalent in the United States through the criticism of Clement Greenberg (as Sharon Patton points out in her essay here). It tended to suppress the signified altogether in a play of (apparently) pure signifiers detached from the duty of referring to objects and events outside the work of art.[19]

Most twentieth-century Westerners were used to perspectival realism, which they believed accurately pictured reality. They had difficulty seeing how an art whose semiotic system departed from a mimetic style could also deal with the real. To them, Picasso's cubism didn't look like it dealt with "real" life (although, of course, it should be remembered that *Les Demoiselles*'s original title, *Le Bordel Philosophique*, revealed its starting point as a reference to prostitutes), so they thought it must be about art alone. By abandoning the realism they were used to, Westerners tended to think they had escaped representation. When they looked at cubism, they thought less about *what* was represented—a person, an emotion, an event—and more about *how* it was represented.

Paying more attention to the structure of the artwork than to what it represented soon gave rise to an even more extreme development: the apparent suppression of the signified altogether. This "non-objective" or "totally abstract" art rejected conventional ways to refer to the world, as did the work of artists like Wasily Kandinsky, Max Bill, Frank Stella, Bridget Riley. Meaning in this work was explained in various ways: as art whose signified was spiritual (Kandinsky); as pure design (Bill); as pure physical presence (Stella); or as the solution to a problem in mathematics, physics, or the physiology of perception (Riley). To many people the connection between what they saw and what it was supposed to mean was so nebulous that they concen-

trated on what they knew was there: the form. Formalism had arrived. And it kept on arriving through the second and third quarters of the twentieth century. The artists and critics who created and promoted the painting, writing, sculpture, dance, and even film that responded to this new aesthetic demand, rejected interpretations that went beyond the signified they intended. The formalist art this generated was defended in terms of presence or pure objecthood; its ranks of artists were effectively closed at the highest levels to all but European and American males (artists like Riley and Anne Truitt have not received the recognition accorded to their male counterparts) who could participate in and benefit from this rhetoric, which was held in place by social and institutional ties.[20]

But what Wollen called the "other" avant-garde followed a principle that had long been fundamental to African American art: that new content, the signified in linguistic terms, demanded innovations in form. Unlike Hutcheon's postmodernism, whose subversive potential was weakened by slippage or expansion within the sign between signifier and signified, Wollen's second avant-garde retained the ability to exert a "defining oppositionality" by exactly this recognition: that new kinds of subject matter demand new formal means for their expression.[21] This "other avant-garde" is typified in the work of Aaron Douglas, James Lessene Wells, El Lissitzky, Sergei Eisenstein, James Van Der Zee, and Marcel Duchamp.[22] Like the modernisms of Picasso, Kandinsky, Bill, Riley, and Stella, the work of the second avant-garde also interrogated the codes of realism and perception. But unlike the hiding, ignoring, or rejection of certain subject matter demanded by formalism, the aesthetic employed by artists of the second avant-garde permitted the use of abstraction (often along with elements of mimetic realism) in order to better enable the artist to express his or her view of the subject matter.

The second avant-garde did not reject metaphor or narrative, but instead used them in new ways—Van Der Zee's and Eisenstein's montaged images—or in ways

that undercut the uses to which they were usually put in academic art—Meta Warrick Fuller in her *Ethiopia Rising*—as Richard J. Powell suggested in an earlier version of his essay in this collection, or Duchamp's "studio portraits" of himself in drag as Rrose Selavy. This group frequently made art to serve social and political revolution; they often resisted racist, sexist, and capitalist coercion. In writing, these two modernisms can be contrasted in the work of T. S. Eliot and Langston Hughes.[23] In painting, one might contrast the flattened images of Patrick Henry Bruce to those of Aaron Douglas, and in sculpture, Richard Serra to Melvin Edwards, as examples of the first versus the second kinds of avant-gardes.

It seems to me that much of what might be called "The African American Postmodern," or, at any rate, much of the art produced by African Americans like Beverly Buchanan and Fred Wilson, has the characteristics of this second avant-garde. These African American artists question the universality of art's meanings (for example, suggest that the relation between the signifier and the signified will vary with different audiences), and alert their viewers to the kinds of power various relations between the signifier and signified are likely to support. But this need not mean that the sign—the thing that the artist makes—must forego its potential for delivering intended reference or meaning, only that its origin in time and place must be acknowledged and that its meanings are open to expansion and even contestation.

As Lowery Sims suggests in Chapter 4, recent multiculturalism resists compartmentalization. Both she and Sharon Patton agree with art historian and critic Judith Wilson that postmodernism's legitimation of diversity has a potentially positive effect. For Wilson, to the extent that the art of all African Americans to one degree or another grows out of the cultural *experience* of being black in America rather than just illustrating it in a way that could also be done by someone who was just an observer, the valorization of an African heritage and the disassemblage of the master narratives of modernism do have something in common. But simply claiming that

this makes the African American aesthetic and postmodernism two versions of the same thing is to set aside the enormous fact that the different cultural experience of Americans of African descent has been forced on them under the erroneous impression that they are necessarily different in some crucial and genealogical way from other Americans.

Uneasy with the idea that an aesthetic could be determined by race, Wilson cited Anthony Appiah's argument, following W. E. B. DuBois, that there is no correlation of biological to cultural characteristics. This is a claim repeatedly articulated in the service of antiracism in American intellectual history. Melville Herskovits repeated it in *The Myth of the Negro Past* (1941). African Americans' ties to Africa were purely "cultural," and not biological, he wrote. But, as Walter Benn Michaels has since observed, such a claim must be elaborated with care. Herskovits followed this assertion with the conviction that it was important that African Americans appreciate—relearn—these ties because, according to Herskovits, a "people that denies its past cannot escape being a prey to doubt of its value today."[24] But as Michaels argues, in linking these two assertions Herskovits "leans more heavily on the concept of racial identity than his culturalist rhetoric suggests. . . . To make what *they* did part of *your* past, there must be some prior assumption of identity between you and them. . . . Herskovits's antiracist culturalism can only be articulated through a commitment to racial identity."[25]

Like Herskovits, both Judith Wilson and Anthony Appiah separate culturally determined experiences from biological inheritance, but like Michaels, Wilson notes a further difficulty: "the fundamental problem with the notion of a black aesthetic [in the visual arts] . . . is that it involves privileging a kind of singular view of African-American art that necessarily obscures the *diversity* of U.S. black artistic production."[26] In Great Britain, too, scholars like Sarat Maharaj ask whether the "complex,

double-dealing turns" of both early and late twentieth-century black art should not "incline us to see what we might gather under the term Black Art as far more cross-grained, conflictive, gear-switching than we have been hitherto prepared to entertain?"[27]

This particular problem with the establishment of an African canon has troubled cultural critics in other disciplines, too. Manthia Diawara told the English department at the University of Minnesota that "such categories as African literature, 'family resemblance,' African tradition, African ethos, etc., by assuming the cultural identity of Africans, leave aside the diversity of desires and the desire for diversity," and Stuart Hall has argued that "'black' is essentially a politically and socially constructed category, which cannot be grounded in a set of fixed, transcultural or transcendental categories and which therefore has no guarantees in Nature. What this brings into play is the recognition of the immense diversity and differentiation of the historical and cultural experience of black subjects."[28]

But in identifying the potential limits of even a culturally derived Africanity, Wilson and Maharaj do not suggest that since culture depends on a falsely universalizing idea of "race," that idea should be abandoned. To the contrary: Since culture depends on a potentially limiting idea of "race," its horizons should be unrestricted, permitting artists and their viewers to use "race" in whatever way is most appropriate, inventive, effective—and exciting—to counteract the kind of essentialism that is most damaging to them in their particular circumstances.

Although, as Wilson suggests, the common interests of African American artists are circumstantial, not intrinsic, they nevertheless represent a lived experience, one that has been both instructive and productive of a type of approach that has since been called postmodern. By at least 1935, when the Harlem Artists Guild was founded, or perhaps even earlier with the formation in 1922 of the Tanner Art

League in Washington, D.C., and continuing through the oppositional stance of New York's Weusi in the 1960s, African American artists by insisting on the distinctiveness of their experience and production anticipated by more than a half century the poststructural critique of formalist modernism's "universality" that is central to the postmodern approach.[29]

This should not be surprising. To those familiar with African art, the idea that a work of art could refer to forces outside itself without imitating the appearance of the outside world would have come as little surprise. To daughters and sons of the Harlem Renaissance, then, whose "fathers," men like Alain Locke, had advised them to reassert their links with African culture, cubism's shifting of attention away from the relation of the signifier to its referent (the classic problem of realism) and towards the relation of signifier and signified within the sign itself,[30] would have been a shift *toward* aspects of some African and African-influenced aesthetics.

The varieties of art in the *Black Art: Ancestral Legacy* exhibition curated by Alvia Wardlaw with Barry Gaither and Regina Perry, art that ranged from the specificities of mimeticism in the paintings of John Biggers and Malvin Gray Johnson to the geometric abstractions of Charles Searles, Matthew Thomas, George Smith, and James Phillips demonstrates this potential.[31] As David Driskell notes in his introduction here, Locke, together with James Porter and James Herring, introduced autobiography, the black subject, and an open-ended attitude about race, ethnicity, sexual preference, and gender as important issues in African American art long before the subject of postmodernism was broached. The self-regarding whiteness of much postmodernism leads Keith Morrison, similarly, to note that for African Americans the concept of pan-African experience is more useful than postmodernism. African art's abstraction, together with its abundant meaning for its intended audience, made apparent an especially open space, one where different perceptions can exist. You can call this postmodern, but at the least, that is putting the cart before the horse.

The trouble between the African American aesthetic and postmodernism is that the aspect of postmodernism that early on received the most attention stemmed from the first avant-garde. That group's stress on the internal relationships of form led it to disregard or disguise political and social issues in their art. High-profile mainstream postmodernism rebelled against the purity of its first avant-garde father by openly borrowing artistic strategies, telling stories, and appropriating images. As the comments of the authors in this collection suggest, *borrowing in art is nothing new.* But as with the abstraction of Wollen's first avant-garde and Hutcheon's modernism, it may be said of much high-profile mainstream postmodernism that the artists who make it evade the political and social implications of the images they borrow (here I am thinking of artists like David Salle and Jeff Koons).[32]

This was antithetical to the historical and political focus of most African American art, at least as regards its position in relation to the dominant European American culture. Some, in fact, have gone as far as to insist that to maintain a distinction between form and substance is to occupy a European American position, not an African American one.[33] The highly touted slippage between even recognizable images and meaning in this kind of mainstream postmodernism became so great that neither social context, the artist's stated intention, nor the viewer's desire could give it anything but a momentary and conditional impact. The possibility of cultural production as a form of resistance to the status-quo seemed to have disappeared.

There is, however, an aspect of postmodernism more compatible to the idea of an African American aesthetic. It was to this aspect of postmodernism that Alvia Wardlaw referred when she noted in her paper at the Hirshhorn Museum's symposium "The African American Aesthetic in the Visual Arts and Postmodernism" that it could be said that African Americans have done what is now called postmodernism for a long time.[34] This syncretic aspect of postmodernism is related to "the other avant-garde." Syncretic postmodernism—work like Renée Stout's, the late work of

Howardena Pindell, Isaac Julien's, Jeff Donaldson's, and Robert Colescott's—appropriates images and strategies. But unlike the first postmodernism, it appropriates not primarily for aesthetic, experimental, or even unstated purposes, but for rather specific social and political goals. Its eclecticisms differ from both the free play of signifiers whose meaning seems to be endlessly deferred (as in Salle), and from attacks on modernism's methods that concentrate on questioning and expanding the definition of art rather than asking what art might do for or in the world.

In this second postmodernism, the references cited and the appropriations made are often, like Renée Stout's, the result of a personal interaction with a cultural background reclaimed. Of the appeal for her of objects and themes like those found in her *She Kept Her Conjuring Table Very Neat* (fig. 3.1), Stout said, "I love the past. It helps me understand how African American experience in America formed us."[35] Helping to clear out the home of the uncle of a friend, Stout saw in the uncle's books and letters the opportunity to construct a past for Dorothy, a woman to whom he sent exotic gifts. Stout's written narrative about *Conjuring Table* describes how Colonel Frank sent Dorothy the pair of beaded slippers in front of the conjuring table.[36]

But the artist also told interviewers she made the slippers herself. "They're not just slippers I got from the secondhand store and laid them there. I traced my foot on foam core and bound them with silk, and beaded the fabric, and did all of that."[37] The point is not whether the slippers were actually Dorothy's or Stout's fabrication. Stout made up both stories. The point is Stout's ability to project and reclaim a history with objects that tell more than one story (these were Dorothy's slippers; I made them myself). The stories represent the two poles—the past and Stout's contemporary self—necessary to complete the task. In her work, objects heavy with associations of past lives (in *Conjuring Table* a feather, chicken bones, an old key, a sepia photograph of a man, a cow's tooth, a beaded gourd rattle), of the sort used in

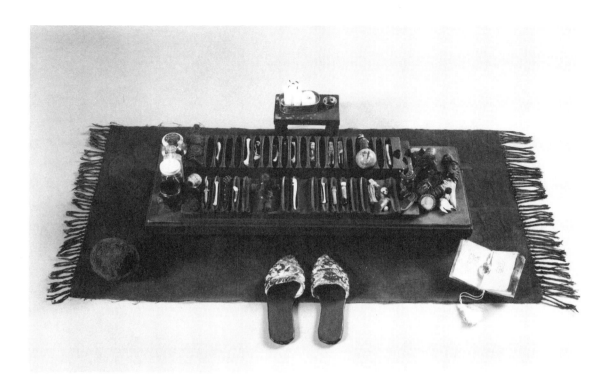

Figure 3.1.

Renée Stout.
*She Kept Her Conjuring
Table Very Neat.* 1990.
Mixed media.
29 × 48 × 9 in.
Collection of
Dr. Regenia A. Perry.
Photograph by Edward
Owen.

magic, ritual, and art, beg the viewer to rhyme their qualities with the associations suggested in Stout's narratives. But they also suggest, as reviewer Mary McCoy noted, a continuation of traditions based on disciplined study, practice, and self-searching.[38]

One of the ways "primitivism" and "colonialism" differ from "ancestralism" and "Pan-Africanism" is in the antithetical versus the shared interests of those involved. Cultural critics such as Michele Wallace, Stuart Hall, Kobena Mercer, Luis Camnitzer, and Cornel West have all suggested that both modernism's and postmodernism's lessons can be constructive.[39] But they can only be constructive when they are recognized as strategies whose aesthetic characteristics always serve someone's political ends, and when their excellence is judged by their effectiveness in both of these areas. Exemplary among the products of postmodernism, in this view, are works of art that reflect the African American aesthetic.

Notes

1. Robert L. Douglas, "Formalizing an African-American Aesthetic," *New Art Examiner* 18 (June/summer 1991): 18–24.

2. Douglas, "Formalizing," 24. For a discussion of the aesthetic claimed by *AfriCobra* see Nuba Kai, "Africobra Universal Aesthetics," in *AfriCobra: The First Twenty Years* (Atlanta: Nexus Contemporary Art Center, 1990), 5–14.

3. Hal Foster, *Recodings: Art, Spectacle, Cultural Politics* (Seattle: Bay Press, 1985), 129.

4. Roland Barthes, *Mythologies*, trans. Annette Lavers (1957; reprint, New York: Hill and Wang, 1972), 113. In this article I am stressing the linguistic underpinnings of postmodernism. Important aspects of poststructural thinking have been developed also in the fields of anthropology (James Clifford), philosophy (Jacques Derrida), literature (Henry Louis Gates Jr.), history (Michel Foucault), gender studies (Judith Butler), sociology (Homi K. Bhabha), psychology (Jane Gallop), history of science

(Donna Haraway), and especially in cultural studies, an area whose broader definition has assimilated the above fields, and that may be said to be in itself a poststructural phenomenon (Stuart Hall, Edward Said, Stephen Greenblatt, Gayatri Spivak, V. Y. Mudimbe).

5. Floyd Coleman identified these in his responses to the papers of Lowery Sims, Alvia Wardlaw, and Sharon Patton presented at the symposium, "The African American Aesthetic in the Visual Arts and Postmodernism," Hirshhorn Museum and Sculpture Garden, March 30, 1991.

6. Beverly Buchanan, excerpt from the legend, *Tribute to Mrs. Mary Lou Furcron,* quoted in Trinkett Clark, "Parameters, Beverly Buchanan," (Norfolk, Va.: The Chrysler Museum, 1992), n.p.

7. Adrian Piper, "The Triple Negation of Colored Women Artists," in *Next Generation: Southern Black Aesthetic* (Winston-Salem, N.C.: Southeastern Center for Contemporary Art, 1990), 18. For a discussion of Euroethnic exclusions of artists of color, see Howardena Pindell, "Breaking the Silence," parts 1 and 2, *New Art Examiner* 18 (October, November 1990).

8. Piper, "The Triple Negation," 18, 22n19. For a summary of writers and positions on postmodernism and truth see Steve Harvey, *The Condition of Postmodernity* (Oxford: Basil Blackwell, 1989), 39–65.

9. For a discussion of Van Peebles in the context of postsoul culture, see Nelson George,

"Buppies, B-Boys, Baps and Bohos," *Village Voice,* March 17, 1992, 26.

10. One now notorious postmodernist, Jean Baudrillard, proclaimed that "the process of signification is, at bottom, nothing but a gigantic *simulation model of meaning."* Jean Baudrillard, "Toward a Critique of the Political Economy of the Sign," in *For a Critique of the Political Economy of the Sign,* trans. Charles Levin, (St. Louis, Mo.: Telos Press, 1981), 160.

11. Molefi Kete Asante, "Location Theory and African Aesthetics," in *The African Aesthetic: Keeper of the Traditions,* ed. Kariamu Welsh-Asante (Westport, Conn.: Praeger, 1993), 60.

12. Robert Douglas develops this perspective in "The Search for an Afrocentric Visual Aesthetic," in *The African Aesthetic: Keeper of the Traditions,* ed. Kariamu Welsh-Asante (Westport, Conn.: Praeger, 1993), 162–64.

13. Lowery Sims too, calls attention to this in her essay in this volume and in "On Notions of the Decade: African-Americans and the Art World," *Next Generation,* 8. See also Kinshasha Conwill, "In Our Own Voices," *Next Generation,* 32.

14. Michele Wallace discusses this in "Modernism, Postmodernism and the Problem of the Visual in Afro-American Culture," in *Out There: Marginalization and Contemporary Cultures,* ed. Russell Ferguson, Martha Gever, Trinh T. Minh-ha, and Cornel West (New York and Cambridge: New Museum of

Contemporary Art and MIT Press, 1990), 39–50.

15. Wallace, "Modernism, Postmodernism," 43. For a discussion of black modernism, see Richard Powell, "The Blues Aesthetic: Black Culture and Modernism," in *Black Culture and Modernism* (Washington, D.C.: Washington Project for the Arts, 1989): 19–35. For African American signifying, see Henry Louis Gates, Jr., "The Blackness of Blackness: A Critique on the Sign and the Signifying Monkey," in *Figures in Black* (New York: Oxford University Press, 1987).

16. Linda Hutcheon, *A Poetics of Postmodernism* (New York: Routledge, 1988), 218–19.

17. Peter Wollen notes this shift without describing it in "The Two Avant-Gardes," in *Readings and Writings* (London: Verso Editions, 1982), 93–101. For a description, see Christine Poggi, "Frames of Reference: 'Table' and 'Tableau' in Picasso's Collages and Constructions," *Art Journal* 47 (winter 1988): 311–22.

18. Recent art and scholarship has begun to contest this view. Like Wilson, Faith Ringgold has also produced a postmodern critique of *Les Demoiselles* in her French Collection series and catalogue, *The French Collection, Part 1* (New York: B MOW Press, 1992). As early as 1980, Linda Nochlin argued for a closer relationship between Picasso's use of color and events in the real world few scholars were ready to admit in "Picasso's Color: Schemes and Gambits," in *Art in*

America 68 (December 1980): 105–21, 177–83. See also Anna Chave, "New Encounters with *Les Demoiselles d'Avignon*: Gender, Race, and the Origins of Cubism," *Art Bulletin* 76 (December 1994): 596–611. Wendy Holmes has discussed the semiotic arguments surrounding Picasso's collage in "Decoding Collage: Signs and Surfaces," *Collage: Critical Views*, ed. Katherine Hoffman (Ann Arbor: UMI Research Press, 1989), 192–202. For an argument that his highly abstract collages were intended and understood as political support for the radical left, see Patricia Leighten, "Picasso's Collages and the Threat of War, 1912–1913," *Art Bulletin* 67, no. 4 (December 1985): 653–72. For Picasso's use of newsprint as flouting "purist" attitudes of the symbolists in intentional references to political and social events, see Christine Poggi, "Mallarmé, Picasso, and the Newspaper as Commodity," *Yale Journal of Criticism* 1, no. 1 (fall 1987): 139–42.

19. Wollen, "The Two Avant-Gardes," 94–95.

20. For an argument to this effect, see Anna Chave, "Minimalism and the Rhetoric of Power," *Arts* 64 (January 1990): 44–62. For the reaction of some African American artists to the situation, see Frank Bowling, "Some Notes towards an Exhibition of African American Abstract Art," in *The Search for Freedom: African American Abstract Painting, 1945–1975* (New York: Kenkeleba Gallery, 1991), 125–28. The position in the 1970s of African American abstractionists such as William T. Williams, Alvin Loving, Howardena

Pindell, and Sam Gilliam deserves attention in this regard.

21. See Wollen, "The Two Avant-Gardes," 93–101, esp. 94–98.

22. This is the historical avant-garde whose movements, Peter Bürger wrote, "negate those determinations that are essential in autonomous art: the disjunctions of art and the praxis of life." Peter Bürger, *Theory of the Avant Garde,* trans. Michael Shaw (Minneapolis: University of Minnesota Press, 1984), 53–54.

23. For a pointed comparison of these two writers in relation to the canon, see Barbara Herrnstein Smith, "Contingencies of Value," in *Canons,* ed. Robert von Hallberg (Chicago: University of Chicago Press, 1984), 11–15.

24. Melville Herskovits, *Myth of the Negro Past* (1941; reprint, Boston: Beacon Press, 1990), 32.

25. Walter Benn Michaels, "Race into Culture: A Critical Genealogy of Cultural Identity," *Critical Inquiry* 18 (summer 1992): 678–80. I think that the answer to this is to note that the "racial identity" assumed by Herskovits is not genealogical, but historically imposed.

26. Judith Wilson, "Part One, The Myth of the Black Aesthetic," in *Next Generation,* 24–26.

27. Sarat Maharaj, "The Congo Is Flooding the Acropolis: Black Art, Orders of Difference, Textiles," in *Interrogating Identity,*

ed. Kellie Jones and Thomas W. Solokowski (New York: Grey Art Gallery and Study Center at New York University, 1991), 14–15.

28. Elliott Butler-Evans, "Beyond Essentialism: Rethinking Afro-American Cultural Theory," *Inscriptions* 5 (1989): 128, quoting Manthia Diawara, "Canon Formation in African Literature," paper presented to the English department, University of Minnesota, Minneapolis, January 19, 1989; and Stuart Hall, "New Ethnicities," ICA Documents 7, "Black Film, British Cinema," 28.

29. Judith Wilson, "Beyond 'Universality' . . . and towards a History of How We Got There," in *Cut Across* (Washington, D.C.: Washington Project for the Arts, 1988): 9–12.

30. Wollen, "The Two Avant-Gardes," 95.

31. Alvia J. Wardlaw, Edmund Barry Gaither, and Regina A. Perry, *Black Art, Ancestral Legacy* (Dallas: Dallas Museum of Art, 1989).

32. Some critics have explored these implications nonetheless. See Joyce Fernandes, "Exposing a Phallocentric Discourse: Images of Women in the Art of David Salle," *New Art Examiner* 14, no. 3 (November 1986): 32–34; and Jeanne Siegel, "Jeff Koons: Unachievable States of Being," *Arts* 61 (October 1986): 66–71.

33. Molefi Kete Asante, *The Afrocentric Idea* (Philadelphia: Temple University Press, 1987), 79.

34. Alvia J. Wardlaw, "Our African Heritage: The Impact of the 'Impulse' in

Contemporary African American Art," (paper presented at "The African American Aesthetic in the Visual Arts and Postmodernism" symposium, Hirshhorn Museum and Sculpture Garden, March 30, 1991).

35. Renée Stout, remarks on her work at "The African American Aesthetic in the Visual Arts and Postmodernism" symposium, Hirshhorn Museum and Sculpture Garden, March 30, 1991.

36. Michael D. Harris, "Roots, Narratives, and Mystery," in "Resonance, Transformation, and Rhyme: The Art of Renée Stout," in *Astonishment and Power* (Washington, D.C.: Smithsonian Institution Press, 1993), 146.

37. For Renée Stout's March 5, 1992 interview with Michael D. Harris, Philip Ravenhill, and David Driskell, see Harris, "Roots, Narratives, and Mystery," 146.

38. Mary McCoy, "The Shapes That Magic Takes," *Washington Post,* 26 January 1991, sec. D.

39. Stuart Hall, "On Postmodernism and Articulation," *Journal of Communication and Inquiry* 10 (summer 1986): 45–50. Hall insisted that marginalized subjects, interpellated from many fragmented social positions, must/will function as concrete historical subjects whose political engagement binds together multiple subject positions. Kobena Mercer, "Why Nobody Likes Black Art: Some Thoughts on the Discourse of Black Aesthetics," (paper presented at the 1991 College Art Association meeting in Washington D.C.); Luis Camnitzer, "The Eclecticism of Survival: Today's Cuban Art," in *The Nearest Edge of the World: Art and Cuba Now* (Brookline, Mass.: Polarities, 1990), 18–23. Wallace, "Modernism, Postmodernism," 39–50; and Cornel West, "The New Cultural Politics of Difference," in *Out There: Marginalization and Contemporary Cultures,* ed. Russell Ferguson, Martha Gever, Trinh T. Minh-ha, and Cornel West (New York and Cambridge: New Museum of Contemporary Art and MIT Press, 1990), 19–38.

4

African American Artists and Postmodernism

Reconsidering the Careers of Wifredo Lam, Romare Bearden, Norman Lewis, and Robert Colescott

LOWERY STOKES SIMS

The age of postmodernism dawned in the 1980s. This was the moment when the art world once again emphasized content in art and welcomed the return of modes and themes that had been preserved in the art of women and so-called ethnic minorities during the formalist era of the 1950s, 1960s, and part of the 1970s. As the art world now romanced figuration and approaches that illuminated identity according to race, gender, and sexual preference, as well as "folk" and "ethnic" traditions, artists of African, Asian, Native American, and Latino American descent attained a modicum of recognition by the art establishment.

The best known of these artists and a forerunner of postmodernism is Robert Colescott. In the 1970s and 1980s, Colescott tackled the exclusion of African Ameri-

cans from art history by appropriating figures from European art and rendering them in "blackface" in a raw, painterly style that has been influenced by popular illustration such as that of comic book art. He arrived at this approach after surveying the "territory" of art history. The arenas that attracted him were the "overlooked corners" of art history, the "popular trash, studio sweepings, or works that didn't pass art history."[1] *Knowledge of the Past Is the Key to the Future: Some Afterthoughts on Discovery* (fig. 4.1) shows his method of deconstructing European traditions, in this case monumental history painting. In this jaundiced view of European colonization, he highlights the anxiety, if not the destruction, of Native Americans and Africans in the Americas and thereby counters the usual laudatory conventions of this genre.

Although some of Colescott's best known works were created in the 1980s, he is at least two generations older than most postmodernist artists who were active in that decade. He matured artistically in the late 1940s and 1950s, before finding his signature style in the 1970s. His training in European modes (he studied with Fernand Léger in Paris) clarified for him the aspects of Eurocentrism that he later set out to deconstruct.

Colescott was a contemporary of Romare Bearden, Norman Lewis, and Wifredo Lam. They began their careers in the 1930s, at the wane of the Harlem Renaissance, a period when African artists in the diaspora sought to reclaim their cultural heritage. This turning to Africa for inspiration in art was also reflected in philosophies known as Afro-Cubanismo, and then, in the post–World War II era, Negritude in the Caribbean and Africa. These three artists continued to work during the liberationist era of the 1960s and 1970s and the era of cultural specificity of the 1980s. Their art signaled the transition from the first wave of "primitivism"—the avant-garde's appropriation around 1900 of motifs from the arts of Africa, Native America, the Pa-

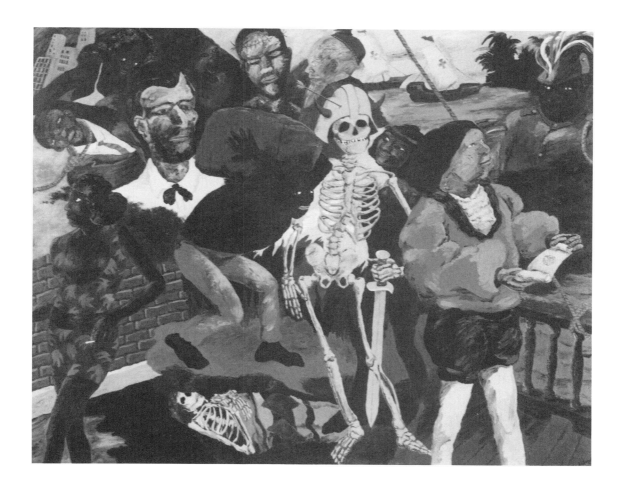

Figure 4.1.

Robert Colescott. *Knowledge of the Past Is the Key to the Future: Some Afterthoughts on Discovery.* 1986. Acrylic on canvas. 90 × 114 in.

The Metropolitan Museum of Art. Arthur Hoppock Hearn Fund. 1987. (1987.166)

cific region, and Pre-Columbian countries—to the second wave. In this later phase, artists such as Bearden, Lewis, and Lam, whose ancestors came from those lands, combined modernist styles with motifs from the traditional arts in a way that reflected their more profound and authentic understanding of the meaning that these forms had for their ancestors. In this sense then, the art of Bearden, Lewis, and Lam heralded the new ideas of postmodernism.

This development was glimpsed during the 1930s by the French surrealist critic Georges Bataille. Writing in the journal *Minotaure,* he took the European avant-garde to task for sanitizing art by focusing on its purely formal qualities.[2] Bataille felt that the appropriation of symbols from the arts of nonwhite cultures had become problematic, as their "transpositioning" negated their primary meaning.[3] The work of Lam, Bearden, and Lewis effected a resynthesis of form and content, symbol and meaning. In the 1940s, Bearden, for example, experimented with a cubist vocabulary for his watercolors and paintings depicting the life of Christ (fig. 4.2). His work can be characterized by what David Driskell described as a combination of "modernism and Africanism in an astonishing synthesis, creating compositions that were spatially flat, formally abstracted."[4] In Bearden's work, the reduction of form to geometric shapes is taken from African art, and the division of the composition into stained glass-like components is an adaption of cubism.

Bearden returned to a cubist style in the 1960s as he experimented with collage. He was looking for a way to express his feelings about the political and cultural revolution that was waged then to achieve equality under the law and a positive self-imagery in art for African Americans.[5] His celebratory vision of African American life came from his own experiences in the African American communities of New York, Pittsburgh, Charlotte, North Carolina, where he grew up, and the Caribbean. But though his subject matter is highly personal, his compositions are marked by the

Figure 4.2.

Romare Bearden.
Golgotha. 1954.
Watercolor, pen and
india ink and pencil on
paper.
$19\frac{7}{8} \times 25\frac{1}{4}$ in.

The Metropolitan
Museum of Art. Bequest
of Margaret Seligman
Lewisohn in memory of
her husband Sam A.
Lewisohn. 1954.
(54.143.9)

symbolic manipulation of scale and proportion found in African art (fig. 4.3). He also proposed the notion that the art of African Americans should be evaluated on its own terms:

> Out of a response and need to redefine the image of man in the terms of the Negro experience, I know best. I feel that the Negro was becoming too much of an abstraction, rather than the reality that art can give a subject. What I've attempted to do is establish a world through art in which the validity of my Negro experience could live and make its own logic.[6]

Bearden had expressed his dissatisfaction with art by African Americans that merely mimicked European modes in 1934. Writing in *Opportunity* magazine, he called for African American artists to find their own artistic philosophy, in part by looking to the art of Africa for inspiration.[7] Alain Locke had counseled, though, that when the African American artist sought to engage "the various forms of African art expression with a sense of its ethnic claims upon him," that artist may do so "in as alienated and misunderstanding an attitude as the average European Westerner."[8] Locke believed that a longtime estrangement from the African continent, as well as "Christianity and all the other European conventions operate to make this inevitable."[9] But the expressive work of Lam, Bearden, and Lewis proved that the effort could be rewarding to the "sensitive artistic mind of the American Negro," as Locke had described:

> But led by these tendencies, there is the possibility that the sensitive artistic mind of the American Negro, stimulated by a cultural pride and interest, will receive from African art a *profound and galvanizing influence* (emphasis the author's).[10]

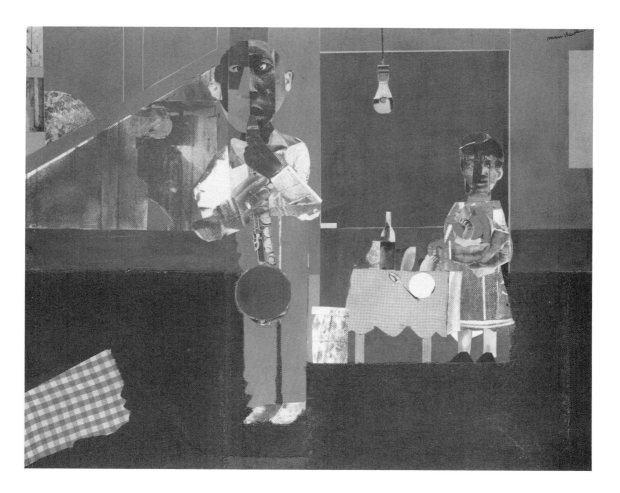

Figure 4.3.

Romare Bearden.
The Woodshed. 1969.
Cut and pasted paper,
cloth, and pencil on
masonite.

40½ × 50½ in.
The Metropolitan
Museum of Art,
Purchase, the George A.
Hearne Fund, by

exchange, and the
Eugene and Estelle
Ferkauf Foundation
Gift. 1991. (1991.47)

Norman Lewis's artistic development during the 1930s and 1940s was, in the words of Ann Gibson, "a complex evolution, a struggle with social and political as well as aesthetic systems of meaning."[11] Lewis experimented with social realism, cubism, surrealism, and pure abstraction before developing in the early 1950s a style characterized by glyphic shapes that in some of his works suggest figures. These elements often formed an all-over design, as in *Untitled* of 1978 (plate 17), or *Processional* of 1965 (fig. 4.4), which evoked the "sit-ins and protest marches of the early 1960s."[12] Gibson notes that aspects of Lewis's abstraction also parodied or formed pastiches of a number of modernist modes.[13] Having the vantage point of the second generation of modernists (Lam was born in 1902, Lewis in 1909, and Bearden in 1912) gave all three a panoply of styles to draw on, from expressionist to surrealist. But Gibson also points out that, as with Lam and Bearden, Lewis's interpretation of modernist motifs not only "involves the mimicry of a style or statement," but also a redirection of its accepted meaning: "a repetition with a difference."[14]

Wifredo Lam realized that using cubist and surrealist styles would give him an edge in gaining access to the art mainstream. That he enjoyed the subversiveness of his strategy was clear when he described himself as a "Trojan Horse."[15]

The story of the Cuban Lam's contact with artists and intellectuals in this country, both white and black, is still being compiled.[16] His early career coincided with the Harlem Renaissance. Given the close relationship of political and social developments in this country and the Caribbean between the two world wars, it makes sense that there would have been artistic ties as well. Lam's identification as an African American artist—in the pan-continental sense—invites discussion about the international scope of African American artistic production right after the Second World War.

Figure 4.4.

Norman Lewis.
Processional. 1965.
Oil on canvas.
38 × 57 in.
Estate of Norman
Lewis.

Like his African American contemporaries, Lam worked to find a mode that would allow him to meld modernist principles with elements of his own culture, a trait of postmodernism. In his case, however, the dynamics were slightly different. Whereas Africanisms were *a* source rather than the *main* source of modernist motifs in Europe and the United States, in Cuba during the 1920s and 1930s, Afro-Cubanismo was the dominant style, tightly bound up with a sense of national identity.[17] Charles Merewether has noted, however, that as an African Cuban working within Cuban modernism, Lam experienced a double encounter with his heritage—both as an avant-garde artist and as a member of an oppressed class.[18] As such, he was aware of the exploitation and trivialization of African Cuban culture in the 1940s in the arts and in the tourist trade:

> I decided that my painting would never be the equivalent of that pseudo-Cuban music for nightclubs. I refused to paint cha-cha-cha. I wanted with all my heart to paint the drama of my country, but by thoroughly expressing the Negro spirit, the beauty of the plastic art of the blacks.[19]

Clearly the challenge for Lam, Bearden, and Lewis was to establish their identity in an era when they were expected to draw on their African heritage, a heritage that had been decontextualized and sanitized in the service of modernism.[20] The motifs from African art that these artists used in the 1930s and 1940s were by that time well-traveled terrain in international art circles. They faced the prospect of being dismissed as imitative in a system that privileged chronological hegemony over all else. Despite Picasso's assertion to the Parisian art dealer Pierre Loeb of Lam's "right" to use African sources in his art[21]—admitting Lam's greater connection to such sources—the presumptions of Western modernism were so strict that even this impri-

matur could not save Lam from intimations of lack of originality. An article entitled "Picassolamming" appeared in *Art Digest* in 1939,[22] and the perception continued as late as 1982, when "Picasso Had Lam for Dinner" was printed in *Artnews*.[23]

Lam ultimately found a solution by combining the formal aspects of cubism and the spontaneous experimentation of surrealism. This gave him a visual framework that correlated with the concepts of African Cuban belief systems: metamorphosis, hybridization, infusion.[24] In *The Jungle* of 1942–1943 (fig. 4.5), Lam deconstructed modernist vocabulary by revealing the cultural origins of its motifs. Invading the geometric vocabulary of cubism, which is essentially urban and European, he infused it with the nature-based world of the orishas of the Yoruba belief system. Thus a new modernism—a postmodernism—was born in this work that not only generated new forms and modes, but also challenged the tenets of the "old" modernism. Tackling the long-standing comparison between Pablo Picasso's *Les Demoiselles d'Avignon* and *The Jungle,* critic John Yau notes of the latter: "the message it embodies . . . is neither self-diminishing nor an homage. Instead it represents a conscious opposition to Picasso's influence and practice."[25] Yau observes that the African figures in Lam's work are "not reductive artifacts to be absorbed into Western perceptual systems,"[26] but are "integrated within nature ("the jungle setting")[27] and thus reclaim their original and rightful place."[28]

Lam, Bearden, Lewis, and Colescott are finally receiving recognition as the forerunners of postmodernism. Monographs have been published on the specifics of their careers. The work of Lam and Lewis, in particular, has been discussed in scholarly articles by David Craven and Ann Gibson that offer a revisionist history of art in New York in the 1940s where Bearden lived and exhibited, and Lam showed his work. The authors have examined some of the lesser known personalities and trends to broaden our understanding of this period.

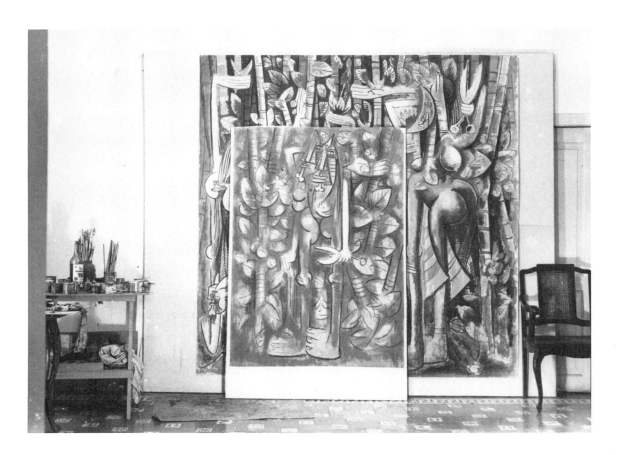

Figure 4.5.

View of Wifredo Lam's studio in Havana with *The Jungle* (l942–1943) and the smaller earlier composition also known as *The Jungle* (1942). Circa 1944. Photograph courtesy SDO Wifredo Lam, Paris.

The greater social, economic, and artistic equality for blacks that resulted from the political initiatives of Africans, African Caribbeans, and African Americans has been examined by David Craven. He views abstract expressionism as an exclusively American mode of art.[29] He interprets the artists' appropriation of African, African American, and Native American motifs as antibourgeois, anti-Western, and as a critique of contemporary society. Craven's inclusion of Lam and Lewis in his article "Abstract Expressionism and Third World Art: A Post-colonial Approach to 'American' Art" is unprecedented but limited: Lam is given equal status with his abstract expressionist peers as ". . . a onetime friend of Jackson Pollock and lifelong socialist who was a firm partisan of the Cuban Revolution until his death in 1982."[30] Lewis fares better and is credited with having appropriated abstract expressionism as a "decentered vocabulary of visual conventions capable of development in a variety of directions," that is, he employed elements of the style of the abstract expressionists and developed them in different ways.[31] Craven also explained the conflicts Lam faced as a Latin American artist who was drawn to surrealism. The problem, according to Craven, involved the bias of European surrealists, whose critique of "Western scientism and instrument thinking constituted . . . both a progressive counter to hegemonic values in the West and a regressive convergence with Western stereotypes about Latin American culture as irrational or unscientific."[32]

The issue of the avant-garde's embrace of African elements and the reality of the racism experienced by artists of color is discussed at length by Ann Gibson.[33] Gibson notes how subjective criteria such as "quality" and "difference" have been used to exclude African American artists from showing in mainstream galleries and museums. In her 1991 study of African American abstract painters, Gibson further notes that the schism between content and form, which characterized critical thinking in the country after the Second World War, affected the status of African American artists:

> The abstraction that became canonical in America and other countries after the Second World War. . . . It was understood by the practitioners and proponents . . . that it would be non-mimetic, that is, it would not quote forms in the everyday world in such a way as to make them immediately recognizable, and if it did, the objects to which the images referred were assumed to be incidental to the meaning of the work.[34]

In the 1950s, the critical establishment shunned recognizable form in art. But for African American artists, regardless of their style, meaning or allusion was key to their expression. Whether it was the "agreed assumptions" described by artist Al Loving or the overt social commentary of Robert Colescott, rarely are "images . . . assumed to be incidental to the meaning of the work."[35]

In 1992, the Cuban critic Gerardo Mosquera wrote of the African American and African Cuban motifs that are present in Lam's work, noting that they exemplify the growing racial diversity in the Americas.[36] This pan-African American aspect of Lam's art was explored in the 1982 exhibition, *Ritual and Myth: A Survey of African American Art,* organized by the Studio Museum in Harlem.[37] In her catalogue essay, art historian Leslie King Hammond grouped Lam with artists she described as representing the second wave of the Caribbean diaspora in the United States, among them, Leroy Clark from Trinidad, Ademola Olugbefola from the Virgin Islands, and Luis Flores, born in Puerto Rico.[38] In the catalogue of the 1992 exhibition, *Wifredo Lam and His Contemporaries, 1938–1952,* held at the Studio Museum in Harlem, art historian Giulio Blanc provided a more concrete link between African American artists in the United States and the Caribbean when he described the relationship of the African Cuban sculptor Teodro Ramos Blanco (1902–1972), to the Harlem Renaissance. Blanc noted that Blanco "was friendly with poet Langston Hughes, whose bust he sculpted, and he corresponded with the collector and scholar Arturo Schomburg."[39]

This exhibition was a barometer of the growing appreciation people in the United States have for African, African Cuban, and Caribbean art. During the 1980s, exhibitions and installations organized at the Studio Museum, the Museum of Contemporary Hispanic Art, and El Museo del Barrio in New York featured African Latino art. Collaborations between artists Charles Abramson and Jorge Rodriguez and the work of Alison Saar (fig. 4.6) dealt with the African cultural traditions shared by people in the United States and the Caribbean. Art historians now realize that many African American artists over the last thirty years forged individual approaches to deconstructing modernist principles. Lam, Lewis, and Bearden expressed their identity with culturally specific motifs—an idea that challenges Clive Bell's concept of "universalism."

New criteria for evaluating art that justly consider issues of identity, ethnicity, gender, sexual preference, and race have begun to change perceptions of the work of artists of color. The importance of these issues to postmodernism has been asserted by Christopher Read:

> Issues of identity are crucial to postmodernism, so much so that some theorists propose a new awareness of certain identities to be *the* defining characteristic of the modern art. . . . Such emphasis on specific identities challenges formalist beliefs in a transcendent or universal art (that just happens to have been created overwhelmingly by and for a specific demographic group: white, Western, apparently heterosexual men of the upper middle class).[40]

Gerardo Mosquera suggests that there needs to be a whole-scale restructuring of art criticism to incorporate the philosophies of art and concepts of beauty of African cultures.[41] For example, in evaluating Lam's work, he would discard the usual comparisons with the school of Paris or the New York school, claiming that Lam's work

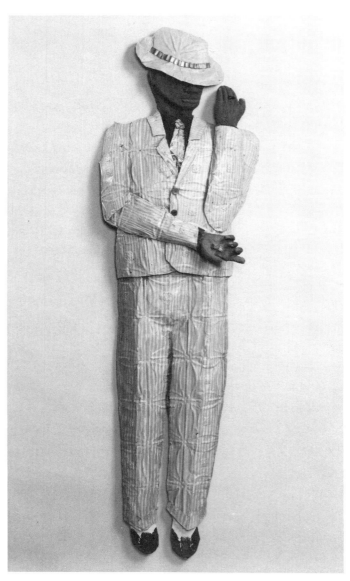

Figure 4.6.

Alison Saar.
Tinto en Tando y Suta.
1985.
Painted tin and plaster,
wood, plastic dice and
ring.
76 × 21½ × 8 in.
The Metropolitan
Museum of Art,
Purchase, Clarence Y.
Palitz Jr. Gift, 1986.
(1986.227)

should be viewed "less as the result of surrealism or the presence of the 'primitive,' the African or African-American in modern art, and more as the fruit of the culture of Cuba and that of the Caribbean."[42]

Mosquera makes the radical suggestion that the work of such artists must be perceived in such a way as to recognize that it is not primitive or traditional—but "the non-traditional artistic production of the Third World . . . a . . . point of true synthesis between avant-garde and 'primitivism,' the possible embryo of a future line of development of art as a result of the eruption of the confines of contemporary culture."[43] He observes that even under European and Euro-American hegemony, many aspects of non-European culture "are no longer 'ethnic' and have become internationalized and intrinsic components of a world shaped by the development of the West."[44]

Such a revision of the tenets of art history would show that the relationship between the center and the periphery is changing. The periphery is moving "towards the center . . . [and] . . . is ceasing to be a reservoir of traditions."[45] World culture, according to Mosquera, "is moving towards a polyfocal, multi-ethical decentralization of 'international' culture combined with a strengthening of local development."[46] This would represent a "dismantling of the History of Art, as a totalizing, teleological story told from the paradigm of Western art . . . to the benefit of a more centralized, ideologizing, integrationist, contextualizing, multi-disciplinary discourse based on hybridization and transformation, open to an intercultural understanding of the functions, meaning and aesthetics of that production and its processes."[47] In the context of this reorientation of art history, then, the contributions of Lam, Lewis, Bearden, and other artists of color could be more readily recognized for their seminal role in defining the postmodern world.

Notes

1. Robert Colescott, artist's statement in Marcia Tucker, *Not Just for Laughs: The Art of Subversion* (New York: New Museum, 1981), 29.

2. Georges Bataille, "L'esprit moderne et le jeu des transpositions," *Documents* 8 (1930): 48–52.

3. Ibid.

4. David C. Driskell, *Two Centuries of Black American Art* (Los Angeles and New York: Los Angeles County Museum of Art and Alfred A. Knopf, 1976), 62.

5. This evolution is chronicled in many studies of Bearden's oeuvre. See Mary Schmidt Campbell and Sharon F. Patton, *Memory and Metaphor: The Art of Romare Bearden, 1940–1987* (New York and Oxford: Studio Museum in Harlem and Oxford University Press, 1991), 39–45.

6. Charles Childs, "Bearden: Identification and Identity," *Artnews* 63 (October 1964): 62.

7. Romare Bearden, "The Negro Artist and Modern Art," *Opportunity* 13 (December 1934): 372.

8. Alain Locke, "The Legacy of the Ancestral Arts," *Voices from the Harlem Renaissance,* ed. Nathan Irvin Huggins (New York: Oxford University Press, 1976), 137.

9. Ibid.

10. Ibid.

11. Ann Gibson, "Norman Lewis in the Forties," in *Norman Lewis: From the Harlem Renaissance to Abstraction* (New York: Kenekleba Gallery, 1989), 9.

12. Elsa Honig Fine, *The African American Artist: A Search for Identity* (New York: Hope, Rinehart, and Winston, 1993), 154.

13. Gibson, "Norman Lewis in the Forties," 15.

14. Ibid.

15. Max-Pol Fouchet, *Wifredo Lam* (Barcelona: Ediciones Polígrafa, S.A, 1976), 189. In a similar mode, Robert Colescott pointed out that appropriation in postmodernism could be a two-way street:

> Picasso started with European art and abstracted through African art, producing "Africanism," but keeping one foot in European art. I began with Picasso's Africanism and moved toward European art, keeping one foot in African art. . . . The irony is partly that what most people . . . know about African conventions comes from Cubist art. Could a knowledge of European art be so derived as well?

See Lowery S. Sims and Mitchell D. Kahan, *Robert Colescott: A Retrospective, 1975–1986* (San Jose: San Jose Museum of Art, 1987), 8.

16. I have been researching Lam's contacts with the New York art establishment in the 1940s. See Lowery Stokes Sims, "Rethinking the Destiny of Line in Painting: The Later Work of Wifredo Lam," *Wifredo Lam: A Retrospective of Works on Paper,* in ed. Charles Merewether, Catherine David, and Lowery Stokes Sims (New York: Americas Society, 1992), 47. There are also several African Americans who met Lam. Painter Herbert Gentry, who has spent over forty years in France and Sweden, told me that Lam frequented the café that Gentry and his first wife ran in Paris in the late 1940s and early 1950s. The African American poet and longtime Paris resident, Ted Joans, also knew him and recruited him for a collaborative art project he had pursued with Lam and several other prominent artists over several years in the 1970s. Sculptor Mel Edwards and poet Jane Cortez encountered Lam in Cuba in the early 1980s. Edwards later dedicated one of his *Lynch Fragment* sculptures to Lam.

17. See Giulio Blanc, "Cuban Modernism: The Search for a National Ethos," in Kinshasha Holman Conwill, Jacques Leenhardt, Giulio V. Blanc, Julia P. Herzberg, and Lowery Stokes Sims, *Wifredo Lam and His Contemporaries, 1938–1952,* ed. Maria Baldaramma (New York: Studio Museum in Harlem and Harry N. Abrams, 1992).

18. Charles Merewether, "At the Crossroads of Modernism: A Liminal Terrain," in Merewether, David, and Sims, *Wifredo Lam: Works on Paper,* 14.

19. Fouchet, *Wilfredo Lam,* 188.

20. See below a discussion of Ann Gibson's chapter on race and the primitivist enterprise in her forthcoming book, *Abstract Expressionism: Race and Gender.* I am grateful to Gibson for making this manuscript available to me.

21. Wifredo Lam, "Mon Amité avec Picasso," in *Wifredo Lam, 1902–1982* (Paris: Musée d'art moderne de la ville de Paris, 1983), 13–14.

22. "Picassolamming," *Art Digest* 17 (December 1, 1942): 7.

23. Michael Gibson, "Picasso Had Lam for Dinner," *Artnews* 82, no. 7 (September 1983): 144.

24. For a discussion of African Cuban religion and Lam see Julia P. Herzberg, "Wifredo Lam: The Development of a Style and World View, The Havana Years, 1941–1962," in Conwill, et al., *Wifredo Lam and His Contemporaries,* 31–51.

25. John Yau, "Please Wait by the Cloakroom," *Arts Magazine* 63 (December 1988): 58.

26. Ibid., 59.

27. Ibid.

28. Ibid.

29. David Craven, "Abstract Expressionism and Third World Art: A Post-colonial Approach to 'American' Art," *Oxford Art Journal* 14, no. 1 (1991): 44–66.

30. Ibid., 49.

31. Ibid., 44.

32. Ibid.

33. Ann Gibson, Steven Cannon, Frank Bowling, and Thomas McEvilley, *The Search for Freedom: African American Abstract Painting, 1945–1975* (New York: Kenkeleba Gallery, 1991), 14.

34. Ibid.

35. Ibid.

36. Gerardo Mosquera, "Modernity and Africania: Wifredo Lam on His Island," in *Wifredo Lam* (Barcelona: Fundació Miró, 1993), 174.

37. Leslie King Hammond, *Ritual and Myth: A Survey of African American Art* (New York: Studio Museum in Harlem, 1982), 28–29.

38. Ibid.

39. Blanc, "Cuban Modernism," 61.

40. Christopher Read, "Postmodernism and the Art of Identity," in *Concepts of Modern Art* (London: Thames and Hudson, 1993). I am grateful to Ann Gibson for bringing this article to my attention.

41. In an ironic way, the deconstruction of formalist theoretical practice brings us back to the problematic place of equating race with aesthetics. The reactions of Meyer Shapiro and James Porter to this issue in the 1930s, in light of the rise of Nazism and other racially biased political ideologies, is instructive. See James A. Porter, "Negro Art and Racial Bias," *Art Front* 4 (June–July 1937): 8–9, and Meyer Shapiro, "Race, Nationality, and Art," *Art Front* 3 (March 1936): 10–12.

42. Mosquera, "Modernity and Africania," 173.

43. Ibid., 173–75.

44. Ibid.

45. Ibid.

46. Ibid.

47. Ibid.

5

African American Postmodernism and David Hammons

Body and Soul

RICHARD J. POWELL

Post Toasties is the only "post" I know.

<div align="right">

DAVID HAMMONS, JANUARY 1992[1]

</div>

▦▍▐▦ Art terminologies, like the artists and art works they attempt to describe, transform themselves, like errant microorganisms, according to the demands of the cultural moment. The terms "postmodernism" and "African American art" are two art concepts that frequently elude clear and concise definitions. For the purposes of this essay, I would like to posit *my own* brief definitions of both terms and—in spite of their very own, fluid natures—proceed to discuss how these two concepts inter-

<div align="right">

121

</div>

sect, especially in a circa 1970 "body print" by contemporary artist and African American postmodernist David Hammons (b. 1943).

Postmodernism is a movement within the contemporary art world that analyzes, criticizes, and/or examines past cultural traditions, styles, trends, and practices. What distinguishes postmodernism from other artistic movements that also comment on previous cultural traditions and styles is its self-conscious and often contentious critical stance. Postmodernism brings into question such formerly inviolable notions as originality, authorship, connoisseurship, the Western European cultural canon, and other "sacred cows." Postmodernism, as its prefix ("post") and word base ("modernism") indicate, positions itself apart from the textbook art historical progressions beginning in the industrial age and moving up through the computer age, preferring instead to see itself as *outside* of history, as reflected in its comfort and ease with visual appropriations from the past. Although much artistic production in the late twentieth century avails itself of new media and electronic technology, postmodernism is especially drawn to these modes of artistic production, since they often underscore the creator's ability to duplicate, alter, and/or probe preexisting cultural data.

African American art is creative work by *and* about peoples of African American cultural descent. African American art, in spite of its often deceptive, modifying clause "African American," is more than simply "all creative work produced by 'African Americans.'" Rather than referring *only* to the *race* or *ethnicity* of the artist, "African American" refers to the major *cultural* practices and traditions of a small but significant segment of the world's population. The creative works that emanate from this cultural group are hybrid in nature, pulling from largely West African and/or Central African cultural traditions as well as from Western European and/or

American cultural practices. Because these two cultural spheres combined under the historical, highly politicized circumstances of (1) the transatlantic slave trade, (2) the Western world's movement toward the abolition of slavery, and (3) the continental United States's struggle toward racial equality, African American art—whether "folk" or "fine," "realistic" or "abstract"—invariably has to do with human values and social concerns.

These two definitions, albeit highly personal ones, function as a basis for further discussion. Recent commentaries by scholars Sharon Patton, Lowery Sims, and Alvia Wardlaw have each addressed the idea that postmodernism and African American art coexist in today's artistic climate and, in numerous instances, even merge into one provocative entity.[2] While I would agree that postmodernism and African American art can and do share the same philosophical space, it might be useful to first discuss how this "fusion" of a contemporary cultural movement with a historical, creative act represents a true *collision* of opposing aims, attitudes, and results.

As suggested in my preceding two definitions, the creative license and contentious nature of postmodernism, especially in regards to the historical past, hit a major roadblock when they encounter the history-sensitive creations that often fall under the rubric African American art. From slave pottery in colonial South Carolina to Henry Ossawa Tanner's *Banjo Lesson,* from Aaron Douglas's "Harlem Renaissance" murals to the contemporary fashions of black urban youth, African American art's relationship with the historical past is an important, even crucial one. Because of the "peculiar" institution of slavery and its legacy of segregation, discrimination, and historical discontinuity for blacks, artists within the African American cultural complex have long valued the didactic and spiritual role that the historical past can play in creative work. Unlike the ambivalent, love/hate relationship that many contempo-

rary postmodernists have with the past, many African Americanists incorporate into their work—usually without discomfort or satire—issues of heritage, lineage, and other historical markers.

This fascination with the historical past among many artists within the African American cultural complex is neither of an ironic nature nor of an unimaginative, documentary type. Instead, what one often finds in African American art is a fluid, but not flagrant, use of former lives, images, testaments, and times; an historical perspective that skillfully weaves the past into the present with a kind of familial, moral underpinning. Two artists/photographers whose works represent these opposing streams—postmodern appropriation versus African American syncretization—are Cindy Sherman and Coreen Simpson. When Cindy Sherman's provocative Untitled Film Stills series (1977–1981) was first shown at the Metro Pictures Gallery in New York City, art-viewing audiences quickly picked up on its sense of satire, its self-conscious, reflexive quality, and its commentaries on a "feminine mystique," as well as on the superficial, often illusory decade of the 1950s (fig. 5.1). By "submerging" her own identities—as the artist and the model—under the twin veils of (1) the anonymous "film stills" photographer, and (2) the unknown "movie starlet" of the 1950s, Sherman unequivocally raised the postmodernist's banner of challenging the integrity of an individuating, artistic vision.[3]

Around the same time that Sherman was creating her Untitled Film Stills series, Coreen Simpson created *Velma James, (Chef)* (1978) (fig. 5.2), a work of art that perhaps has more in common—formally and thematically—with the works of the great documentary photographers of this century than it does with works by artistic contemporaries like Cindy Sherman. Its knowing, impromptu quality, along with its evocative *iconization* of the principal subject—a black female chef—easily puts this photograph by Simpson into the ranks of classic examples of African American art.

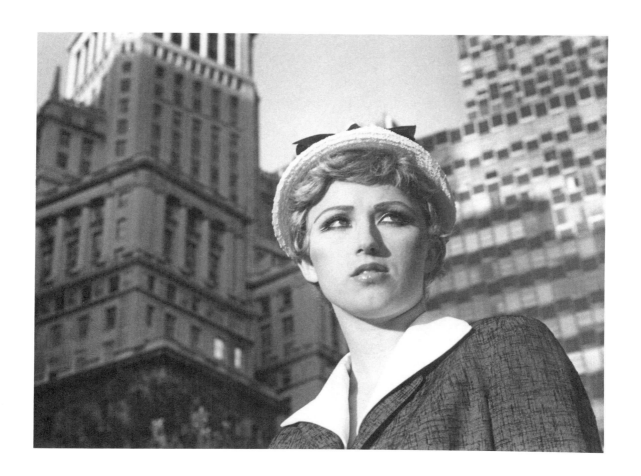

Figure 5.1.

Cindy Sherman.
Untitled Film Still #21.
1978.
Metro Pictures.

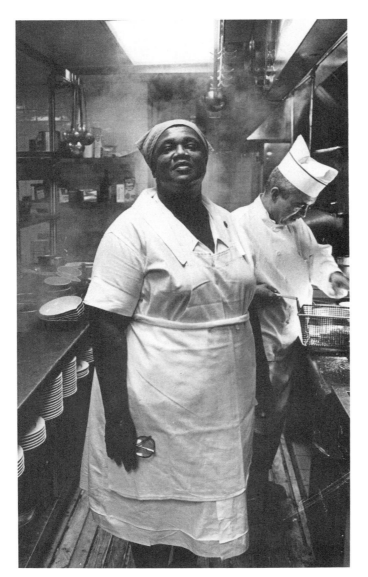

Figure 5.2.

Coreen Simpson.
Velma James. (Chef).
1978.
8 × 10 in.
Black and white
photograph. Courtesy of
the photographer.

Simpson's subtle mixing of expressive, graphic elements (the interplay of dark and light and the use of diagonals) with an engaging, human interest subject *of African ancestry,* underscores this photograph's unambivalent position (in contrast to Sherman's Untitled Film Stills series) vis-à-vis modernism and notions of cultural identity.[4]

Given this society's long history of racial discrimination, one might assume that African Americanists would naturally share the postmodernist's ideological contempt for linear art histories and traditionally tiered and hierarchied art institutions. Yet, as one closely examines the directions and objectives of many contemporary African Americanists, one finds that a significant number of them are even greater adherents to art traditions, institutions, and historical edifices than those who have historically partaken of those systems and structures and now choose to reject them. While admittedly there is at present a small, highly visible contingent of African American postmodernists within the contemporary art world, the overwhelming majority of contemporary African Americanists see their efforts as part of a long and historic African American cultural tradition. They perceive themselves as neither artistic *outsiders* nor ideological *others* but rather as *neglected participants* in the entire modernist and American art enterprise. The visual asides and contextual critiques that these artists engage in, in contrast to those by their postmodernist counterparts, are firmly grounded in a kind of collective, cultural understanding that, when viewed by members of the same community, clearly resonates with them in terms of shared experiences, common visions, and recollected narratives.[5]

But the question arises: Who are the African American postmodernists? And this question is followed by: What is it about their work that is considered "postmodern," and what is it about this work that could be described as "African American?"

In response to the first question, most critics would probably agree that the term African American postmodernist best describes the Harlem-based artist David

Hammons. Although other contemporary artists (like Adrian Piper, Carrie Mae Weems, Danny Tisdale, and Fred Wilson, just to name a few) certainly explore similar philosophical terrains in their respective works, Hammons is, by far, the best known of this particular kind of postmodernist. From his body prints of the late 1960s to his more recent environmental "pieces," Hammons has continually juggled late twentieth-century critiques of artistic and social hierarchies with his own special versions of black history and culture, resulting in a body of work—art objects, temporary installations, and cultural events—that genuinely fit into the two, seemingly disparate, categories of postmodernism and African American art.

For many longtime enthusiasts of African American art and culture, we first learned about artist David Hammons from Samella Lewis's and Ruth Waddy's classic, two-volume set of biographical listings, photographs, and personal testimonies of artists, *Black Artists on Art,* published in 1969. Hammons, then in his mid-twenties and a product of the Chouinard and Otis Art Institutes in Los Angeles, had made a name for himself among West Coast and younger black artists with his combination silkscreen/body prints.[6] Almost a decade later, in Linda Goode Bryant's *Contextures*—an important study of post-minimalist, abstract tendencies in the works of contemporary African American artists—the art of David Hammons is again prominently featured, this time in the guise of assembled and contextualized African American *detritus* (shorn human hair and food remnants).[7] From about 1980 onward, David Hammons's reputation in the art press steadily grew, and coverage of him ranged from brief, perceptive reviews of his work to lengthy interviews with him about his work and position in an increasingly profit-driven New York art world.[8] Although various artists, critics, and curators had known about his highly conceptual, African American–inspired creations for some time, it wasn't until the highly publicized controversies surrounding several of his installations of the late 1980s that

his work became known in a broader, more international sense.[9] These controversies, coupled with a shift in the art world away from art objects *proper* and toward temporary installations, art events, and conceptual creations, established David Hammons, the quintessential art "outsider," as one of the major figures in the art world of the early 1990s.[10]

But apart from Hammons's steady ascent within the 1980s and 1990s art world, his work stands as a barometer of a gradual shift within the African American art community away from espousing modernist formulas and post-Aaron Douglas principles of visual historicizing and toward advocating a clean break from past socio-aesthetic, historical conventions by means of (1) assemblage, and (2) visual/verbal signification. What makes David Hammons's contribution all the more significant is that as early as 1970, at the height of the thematically radical/stylistically uneven Black Arts movement in the United States, he had inaugurated an approach to subject matter, style, and art materials that signaled the beginnings of African American postmodernism before there was a name for it. In order to make sense out of these fused concepts, it will be useful to look back at this earlier phase of Hammons's career, in an attempt to place it and his most definitive work during this period in the framework of what seems to be a career-long interest in postmodern demolition and, simultaneously, African American cultural retrieval.

Injustice Case (fig. 5.3), a 1970 homage to former Black Panther Party leader Bobby G. Seale, represents David Hammons's most fully realized body print of this period. Seale, who was bound and gagged in a Chicago courtroom during a controversial, highly publicized trial in 1969, is depicted here in an image that would have been all too familiar to audiences, circa 1970.[11] As with other body prints by Hammons, the artist created impressions on the surface of the paper by (1) covering his own body and parts of a chair with grease, (2) pressing himself and these objects on

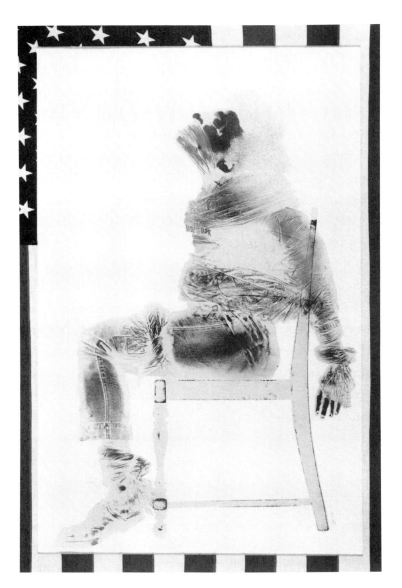

Figure 5.3.

David Hammons.
Injustice Case. 1970.
Mixed media print.
63 × 40½ in.
Los Angeles County
Museum of Art.

the paper, and (3) applying powdered pigment to the greasy areas where it created a contrasting image.[12] While other body prints by Hammons (*America the Beautiful, American Hang Up,* and *Pray for America*) often incorporated silkscreened images of the American flag, *Injustice Case* sported an actual flag as a framing device.

Apart from the obvious political messages in this work, *Injustice Case* suggested alternative thematic perspectives for Hammons. The materials and methods employed in *Injustice Case* foreshadowed Hammons's continuing preoccupation with *himself* as a validating and authenticating artistic vehicle. Although a continent and ocean apart from the experiments in performance and body arts that were taking place among European artists in the 1960s, Hammons's brash, self-locating body prints represented an American—specifically African American—response to this new-found fascination among world artists in themselves-as-art.[13]

On the other hand, Hammons's insertion of himself within *Injustice Case* presaged the *"self"-as-subject* explorations of many subsequent postmodernists. Like the semiautobiographical/self-portrait works of Jeff Koons, Adrian Piper, Lorna Simpson, and David Wojnarowicz, Hammons, through his body prints, had discovered the analytic possibilities and declarative potential of representing *the self* in his art.

Of course, in the context of black America, these life-sized, transferred images of denim, hair, and flesh conjured all sorts of references to identity and ethnicity at a time in United States history when questions about black self-awareness were constantly being raised. Hammons's inclusion of the American flag in *Injustice Case* further addressed this idea of self-definition, in terms of a national identity (for example, being a black *American*), and in terms of an identity based on a view of one's self as a victim of government-sanctioned social disenfranchisement and political oppression.

What separated *Injustice Case* from the majority of race conscious and politically charged works of the late 1960s and early 1970s, however, was Hammons's pervasive, uncanny blend of self-referencing and culture-referencing in his work. Traces of David Hammons, as evidenced in the greasy residue and dark powdered pigments, invested this work with a personal stamp and cultural specificity that was simply unattainable through more illusionistic devices. Perhaps in an even more provocative line of thinking, the grease stains that marked the presence of the artist also alluded to traditional African American cosmetics and "beauty culture," as well as to traditional African American cuisine (which has historically used large amounts of animal fats). One need only to flip through the pages of *Ebony, Jet,* and other popular African American publications to understand the *psychic* weight that hair, food, and other cultural emblems have had in the African American community.[14]

It was this conscious yet *playful* use of language and visual signs by Hammons that moved *Injustice Case* and subsequent works out of the realm of the ordinary and into another intellectual sphere. Hammons's strategy is deceptively straightforward: he takes a culture-based concept or notion—for example, American "justice" (or rather, "injustice")—and gives that concept a jarring, aberrant, and/or unorthodox image—a real life impression of a bound and gagged black man framed by an American flag. At this point the work is in the domain of his audience, who are free to travel the interpretive spaces between the original concept and Hammons's representation of it. Like many contemporary writers (for example, Ishmael Reed, Amiri Baraka, Greg Tate) and jazz musicians (for example, Thelonius Monk, Miles Davis, Ornette Coleman), Hammons extends creative license to his audience in interpreting the work, yet the multiplicity of concepts are collectively understood well enough, and his representations of them are startling and recognizable enough, that the final effect is not unlike the conscientious discernment by scientists of *mascon-*

like materials beneath the surface of the moon: dense, meaning-filled, yet ultimately fathomable. Although Hammons's visual/verbal significations might not completely translate in the eyes and minds of many critics, most postmodernist and African Americanist audiences immediately identify and understand the links between the image, medium, message, and the culture.[15]

After the body prints of the late 1960s and early 1970s, Hammons continued to delve further into the iconography and "spirit" of African America. Whether the works introduce actual artifacts (records, basketball hoops), visual puns (shovels, coal), or organic, "ethnic" debris (African American hair, barbecue bones), one sensed in these works a different kind of visual poetry which really hadn't been seen before in the art world. Although analogies exist between Hammons's assemblages and the works of Ed Kienholz and Joseph Beuys, Hammons's sense of spirituality and cultural identity sufficiently removes his assemblages from other works in this vein. While Hammons's insistence on a mystical element in his work resonates with several Los Angeles-based assemblagists (Simon Rodia and Bettye Saar, for example), his strong identification with the black community, coupled with his selective application of *used* (for example, spiritually charged) materials, tie this mystical side of his work to the very pragmatic, artistic/religious traditions of Africa, specifically the spiritually activated and accumulative oath-taking and healing sculptures created by Kongo artists in lower Zaire.[16] Hammons's often quoted statement about the spiritual overload that comes from using the black community's refuse in his art is in perfect, philosophical accord with Kongo thought.[17] In looking at Hammons's work as not only *art* but *commentary,* one is perhaps justified in thinking about it as culturally attuned, postmodern "Black Codes."[18]

Returning, then, to the question, "What is postmodern and what is African American about David Hammons's work," the answer is, as one might suspect, not

so simple. On one hand, Hammons's disinterest in traditional materials, tools, and approaches to art-making puts him firmly in the ranks of the postmodernists. The biting irony and wry humor that he frequently uses in his art, and the negative responses of the perceived recipients of these visual/verbal barbs, often put him at odds with many African Americanists, who rarely are portrayed in as provocative a light as Hammons is. The multiple layers of meaning that he employs in his work, while not solely a characteristic of postmodernism, contribute to the postmodernist edict for obfuscating and questioning long-held societal and cultural assumptions.

On the other hand, Hammons's principal source of inspiration and information is African America. His excavations of black language and metaphor, cultural icons, and racial/ethnic symbolism are legendary in the annals of African American art. And, in spite of the sometimes controversial and contentious nature of his work, much of it is seen and understood as coming from a position of knowledge and awareness of, insight into, and empathy for African Americans.

Consequently, how successful one can be in separating the postmodern elements in Hammons's work from the African American aspects is debatable. Much of the debate and dilemma stems from the fact that Hammons, as the mind behind these works, does not see a separation between these two spheres of influence. For him, the work is of one, highly personal frame of reference, whose origins are inextricably tied to the past *and* present. For example, when asked by an interviewer about his perceived silence on the subject of other African American artists, Hammons replied, "Without them, I wouldn't be making art, but at the same time I can't afford to make art their way. Basketball is closer to what I'm about—the art of improvisation." [19]

As suggested by Alvia Wardlaw's writings on the *idea* of Africa in African American art, Hammons's postmodernism is in part nourished by an African *impulse:* a conscious and/or unconscious overture to the past—real or imagined—that encour-

ages an art of spirituality and remembrance.[20] Hammons's postmodernism is similarly affected by what Sharon Patton has described as a collage/assemblage sensibility—rooted in a decorative aesthetic—which is often present in the works of African American women artists.[21] And finally, Hammons's postmodernism is conditioned to a great extent by what Lowery Sims has described as "the Black Art debates": arguments that—because of their preoccupation with terminology, art world status (or the lack thereof), and the dialectic between artistic expressivity ("hot") and artistic detachment ("cool")—have triggered in Hammons his own, idiosyncratic, visual discourse on the lengths to which aesthetic *blackness* can be stretched.[22]

Hammons's interjection, through *Injustice Case,* of his *own* African American body *and* soul into the public arena marked a decided shift in American visual culture: an artistic detour that has yet to receive the real recognition that it deserves. This artistic overture, made in remembrance of African Americans ranging from the anonymous, shackled slave on "Am I Not A Man And A Brother" eighteenth-century English medallions to Black Panther Party leader Bobby Seale, has an eery, déjà vu counterpart in the recent, widely seen, video image of police brutality and "injustice case" victim Rodney King.[23] David Hammons's legacy to late twentieth-century art might very well be the rediscovery, through postmodern conventions, of an art of spiritual, social, and political dimensions, all within the boundaries of an unflinchingly critical, African American perspective.

Notes

1. From a conversation between David Hammons and Louise Neri, "No Wonder," *Parkett* 31 (1992): 52.

2. These comments were made in conjunction with the symposium, "The African-American Aesthetic in the Visual Arts and Postmodernism," organized by scholar and art museum educator Teresia Bush and held on Saturday, March 30, 1991, at the Hirshhorn Museum and Sculpture Garden, Smithsonian Institution, Washington, D.C.

3. See Arthur Danto, *Cindy Sherman: Untitled Film Stills* (New York: Rizzoli, 1990) and Andy Grundberg, "Cindy Sherman: A Playful and Political Post Modernist," *New York Times,* 22 November 1981, Sec. 2, 35.

4. See Deborah Willis-Thomas, *An Illustrated Bio-Bibliography of Black Photographers, 1940–1988* (New York: Garland Publishing, 1989), 128–30, and Richard Powell, "Style as Power," in *The Blues Aesthetic: Black Culture and Modernism* (Washington, D.C.: Washington Project for the Arts, 1989), 79–81.

5. Michele Wallace, discussing the often inherent racism of contemporary critics, both modernist *and* postmodernist, writes:

> While the most concrete sign of that something new is generally referred to as Postmodernism, unfortunately this move usually carries along with it the reinscription of Modernism's apartheid. Although the negation of their former powers to explain the world is potentially useful to counter-hegemonic strategies, invariably European influenced theorists are so preoccupied with the demise of the Hegelian dialectic that they never really get to anything or anyone other than white men who also share similar feelings. . . .

See Michele Wallace, "Modernism, Postmodernism and the Problem of the Visual in Afro-American Culture," in *Out There: Marginalization and Contemporary Culture,* ed. Russell Ferguson (Cambridge, Mass.: MIT Press, for the New Museum of Contemporary Art, 1990), 49.

6. Samella S. Lewis and Ruth G. Waddy, *Black Artists on Art* (Los Angeles: Contemporary Crafts, 1969), 1:101–2, 126.

7. Linda Goode-Bryant and Marcy S. Philips, *Contextures* (New York: Just Above Midtown, 1978), 40–43.

8. For two examples of 1980s art criticism on David Hammons, see Robert Hughes, "Going Back to Africa—as Visitors," *Time* 115 (31 March 1980): 72; and Kellie Jones, "David Hammons," *REALLIFE* 16 (autumn 1986): 2–9.

9. The most publicized of these controversies was the vandalizing and knocking

down of an approximately 16-foot high painted metal billboard by a group of disgruntled pedestrians in Washington, D.C., on November 29, 1989. The billboard, commissioned from David Hammons by the Washington Project for the Arts and, significantly, standing across the street from the Smithsonian Institution's National Portrait Gallery, was an image of a blonde-haired, blue-eyed, and white-skinned version of the popular civil rights leader Jesse Jackson. It carried the caption and title *How Ya Like Me Now,* taken from a popular recording of the day by rap artist Kool Moe Dee. Hammons, who was in Rome, Italy, at the time of the incident, has subsequently utilized the billboard's tumultuous history by exhibiting it, dents and all, with sledgehammers.

10. His having received (in 1991) the prestigious MacArthur Foundation "genius" Award and his appearance (also in 1991) in the much heralded *Dislocations* exhibition at the Museum of Modern Art, New York (from October 1991 to January 1992) are two examples of Hammons's new found notoriety and recognition. See Robert Storr, *Dislocations* (New York: Museum of Modern Art, 1991).

11. See J. Anthony Lukas, "Seale Put in Chains at Chicago 8 Trial," *New York Times,* 30 October 1969, sec. 1, 39.

12. For vintage photographs (circa 1972–73) of Hammons creating body prints, see Kellie Jones, Tom Finkelpearl, and Steven Cannon, *David Hammons: Rousing the Rubble* (Cambridge, Mass.: MIT Press, 1991), 10–13.

13. For a brief but informative discussion about early performance and body arts activities in Europe, see Kristine Stiles, "Notes on Rudolph Schwarzkogler's Images of Healing," *Whitewalls* 25 (spring 1990): 11–26.

14. In the following excerpt from the epic poem "For My People," one can see the iconic aspects of selected cultural emblems: "For my playmates in the clay and dust and sand of Alabama / backyards playing baptizing and preaching and doctor and / jail and soldier and school and mamma and cooking and / playhouse and concert and store and hair and Miss Choomby / and company. . . ." See Margaret Walker, "For My People" (1942), in *Cavalcade: Negro American Writing from 1760 to the Present,* ed. Arthur P. Davis and Saunders Redding (Boston: Houghton Mifflin, 1971), 528.

15. For my discussion of David Hammons's body prints in the context of other graphic works by contemporary African American artists, see Richard J. Powell, "Current Expressions in Afro-American Printmaking," *PrintNews* 3 (April/May 1981): 7–11.

16. For an examination of these oath-taking and healing figures, see Ezio Bassini, "Kongo Nail Fetishes from the Chiloango River Area," *African Arts* 10 (1977): 36–40, 88.

17. "I was actually going insane working with that hair so I had to stop. That's just how potent it is. You've got tons of people's spirits in your hands when you work with that stuff. The same with the wine bottles. A Black person's lips have touched each one of those

bottles, so you have to be very, very careful." David Hammons, as quoted in Kellie Jones, "David Hammons," *REALLIFE* 16 (autumn 1986): 4.

18. The writer who, to date, has best summed up this idea of Hammons as the consummate African American cultural critic is Calvin Reid in "Kinky Black Hair and Barbecue Bones: Street Life, Social History, and David Hammons," *Arts* 65 (April 1991): 59–63.

19. From David Hammons and Louise Neri, "No Wonder," *Parkett* 31 (1992): 52.

20. Alvia J. Wardlaw, "Our African Heritage: The Impact of the 'Impulse' in Contemporary African American Art" (paper delivered on the occasion of the symposium, "The African-American Aesthetic in the Visual Arts and Postmodernism," 30 March 1991, at the Hirshhorn Museum and Sculpture Garden, Smithsonian Institution, Washington, D.C.).

21. Although by no means a *feminist* artist, David Hammons has been influenced and informed, to a great extent, by a number of women artists, including Bettye Saar, Senga Nengudi, and Maren Hassinger. Also see Sharon F. Patton, "The Agenda Now: Socially Conscious Art and the Feminist Perspective" (paper delivered on the occasion of the symposium, "The African-American Aesthetic in the Visual Arts and Postmodernism," 30 March 1991, at the Hirshhorn Museum and Sculpture Garden, Smithsonian Institution, Washington, D.C.).

22. Lowery S. Sims, "Black Artists: Modern and Postmodern" (paper delivered on the occasion of the symposium, "The African-American Aesthetic in the Visual Arts and Postmodernism," 30 March 1991, at the Hirshhorn Museum and Sculpture Garden, Smithsonian Institution, Washington, D.C.).

23. For a classic example of Josiah Wedgewood's medallion of a shackled slave in profile, see Hugh Honour, *The Image of the Black in Western Art 4: From the American Revolution to World War I*, Part 1 (Cambridge, Mass.: Harvard University Press, 1989), 62.

Contributors

David C. Driskell is widely recognized as an artist, art historian, curator, and frequent writer on the subject of African American art. He holds the title of Distinguished University Professor of Art at the University of Maryland at College Park.

Ann Gibson, an associate professor at the State University of New York at Stony Brook, teaches twentieth-century art history and criticism. She is author of *Issues in Abstract Expressionism* and is completing a book on abstract expressionism, race, and gender. Her articles have appeared in such journals as *Artforum, Artist and Influence, Genders, Art Journal, Black American Literature Forum, Arts, Kunstforum, Art International, Journal of Homosexuality,* and *Yale Journal of Criticism.*

Keith Morrison is a Jamaican-born artist, curator, and art educator and critic. His paintings, drawings, and prints have been shown internationally and are in the collections of the Art Institute of Chicago, the Corcoran Gallery of Art, the National Mu-

seum of American Art, the Philadelphia Museum of Art, the Pennsylvania Academy, and the Jamaica National Gallery. His art criticism has appeared in such journals as the *New Art Examiner.* He is author of *Art in Washington and Its Afro-American Presence,* as well as several exhibition catalogues. He has curated exhibitions for institutions such as the Washington Project for the Arts, the University of Chicago, and the Brandywine Workshop. He is presently professor of art and dean at the College of Creative Arts, San Francisco State University.

Sharon Patton, an art historian and curator, is currently associate professor of art history in the University of Michigan's Department of the History of Art and Center for Afroamerican and African Studies. Patton received her Ph.D. in art history from Northwestern University. She is the former chief curator of the Studio Museum in Harlem, where she curated a major retrospective exhibition on Romare Bearden, *Memory and Metaphor: The Art of Romare Bearden.*

Richard J. Powell, associate professor of art history at Duke University, has written extensively on African American art and culture, including essays in edited collections, journals, and exhibition catalogues. His major publications include *The Blues Aesthetic: Black Culture and Modernism* (1989), *Homecoming: The Art and Life of William H. Johnson* (1991), and *Black Culture and Art in the Twentieth Century* (forthcoming). Powell received his Ph.D. in art history from Yale University.

Lowery Stokes Sims, curator of twentieth-century art at the Metropolitan Museum of Art, has written extensively on twentieth-century art, with an emphasis on African American, Native American, Asian American, and Latin American art. She received her Ph.D. in art history from the City University of New York in 1995.